BARRY EVERSON

		-

One Hundred Figure Drawings

-				

One Hundred Figure Drawings

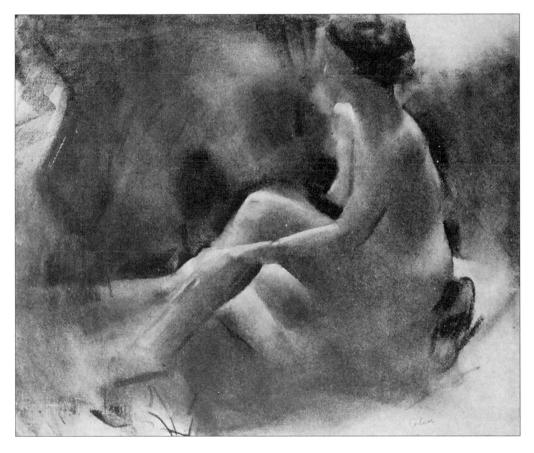

Edited by George B. Bridgman

Dover Publications, Inc., Mineola, New York

Bibliographical Note

This Dover edition, first published in 2009, is an unabridged republication of the work originally published by Bridgman Publishers, Inc., Pelham, N.Y., in 1935 under the title *The Book of One Hundred Figure Drawings*.

Library of Congress Cataloging-in-Publication Data

Book of one hundred figure drawings.

One hundred figure drawings / edited by George B. Bridgman. — Dover ed.

Originally published: The book of one hundred figure drawings. Pelham, N.Y.: Bridgman Publishers, 1935.

ISBN-13: 978-0-486-47030-6

ISBN-10: 0-486-47030-X

I. Human figure in art. 2. Drawing, American. I. Bridgman, George Brant, 1864–1943. II. Title.

NC765.B6 2009 743.4—dc22

2009003266

Manufactured in the United States by Courier Corporation 47030X01 www.doverpublications.com

INTRODUCTION

Late in February, Nineteen Hundred and Twenty-seven, an invitation was forwarded to the leading Art Schools in this country requesting them to submit to a Jury, directed under the supervision of George B. Bridgman of the Art Students League of New York, their best examples of student work completed during that year in the various Life Classes of these Schools. The Jury selected fifty of the best figure drawings submitted at that time. The result was, that the material was published in book form in April, Nineteen Hundred and Twenty-seven.

In September of that year a second and larger printing was released. In April, Nineteen Hundred and Twenty-nine, this book was so much in demand that a still larger edition was printed. The fourth edition was printed in July, Nineteen Hundred and Thirty-one, and in November, Nineteen Hundred and Thirty-three, a fifth edition. So great and so consistent has been the demand from individual requests, both from students and instructors, that on January Twenty-fourth of this year, special invitations were sent to the ranking Art Schools in the country, with the result that a tremendous amount of material was submitted, judged and considered. From these drawings, one hundred and ten were chosen for reproduction. Ten prizes in all were given for the best ten drawings.

The Jury have expressed their regret that so many fine contributions were not chosen because of the lack of space. An analysis of these one hundred and ten drawings reproduced, shows a very definite impulse of a new movement gradually taking place throughout the Art Schools in this country. The approach is more direct and energetic; a greater diversity of style, technique and character is very marked. As well, there is a greater variance in the work of the different individuals in the same classes than the Jury has seen in previous reviews. This is particularly noted when one school's work is compared with that of another school.

The drawings themselves show that there has been a decided change of viewpoint regarding the drawing of the human figure. Students have broken away from the old formula and rules they have heretofore been taught to follow.

Apparently it appears from the drawings submitted, that the Art Schools as a whole, are constructive conscious. That the student is really making, or is being instructed to build his drawings rather than relay impressions. There are on the following pages many phases and influences, but in all a noteworthy evidence of self-expression. There is also a most striking sympathic unity in their ideals, which is very evident in their drawings.

The purpose of this book is to show graphically, the exhibits of the finest work done in Life Classes by students in the ranking Art Schools in this country. It is in reality a handbook of figure drawing, definitely illustrating the varied styles, techniques and artistic expression of the human figure.

In the production of this volume, we hope that the absence of critical text will tend to encourage and stimulate interest, offer innumerable suggestions to both student and instructor, and will only be a forerunner of a series which will become a permanent and official guide for the advancement and success of the various student's work whose ability deserves recognition. It is quite probable that this book will be looked upon in the years to come, as a most remarkable permanent record of style technique, graphically portraying this present age of draftsmanship.

The reproductions have been made in halftone and line, direct from the originals in charcoal, pencil, wash, pen and ink and crayon.

It is regretted that our pages are limited, or we should feel tempted to reproduce all the drawings submitted. We have, as you will note, gone considerably over the original one hundred reproductions prescribed.

We dedicate this book to you Art Students and Instructors, who have so loyally supported and furnished the many fine drawings herewith reproduced, and to you, we express our sincere appreciation and thanks.

THE PUBLISHERS

TABLE OF CONTENTS

FRANCES COHEN, Pupil of Arthur Meltzer, Moore Institute of Art, Science and Industry, Philadelphia School of Design, Philadelphia, PaTitle
R. HOOK, Pupil of Ralph McLellan, School of Industrial Art, Philadelphia, Pa8
MOLLY WHEELER WOOD, Pupil of Robert Rushton, Pennsylvania School of Industrial Art, Philadelphia, Pa
C. O'TOOLE, National Academy of Design, New York City, N.Y
PETER DUBANIEWICZ, Pupil of Henry G. Keller, Cleveland School of Art, Cleveland, Ohio
MARION VAN DYKE, Pupil of Henry G. Keller, Cleveland School of Art, Cleveland, Ohio
HERBERT SPIGEL, Pupil of George Harding, School of Fine Arts, University of Pennsylvania, Philadelphia, Pa
ED. MICHNER, Pupil of Ralph McLellan, School of Industrial Art, Philadelphia, Pa
STANLEY PERKINS, Pupil of A. B. Wright, University of Utah, Salt Lake City, Utah 16
CARL BRANTIGAN, Pupil of Byron G. Culver, Department of Art, Mechanics Institute, Rochester, N.Y
GLEN BURTON, Pupil of Elmer E. Taflinger, Elmer E. Taflinger Studio Art School, Indianapolis, Indiana
ELIZABETH SABIN, Pupil of S. Burtis Baker, Corcoran School of Art, Washington, D.C 19
R. D. WILLIAMS, Pupil of M'Cullough Partee, Watkins Institute, Nashville, Tenn
PAUL JONES, Pupil of Elmer E. Taflinger, Elmer E. Taflinger Studio Art School, Indianapolis, Indiana
WILLSON Y. STAMPER, 3rd, Pupil of Kimon Nicolaides, Art Students League, New York City, N.Y
JOHN L. CABORE, Pupil of George B. Bridgman, Art Students League, New York City, N.Y

ROGER FREY, Pupil of Elmer E. Taflinger, Elmer E. Taflinger Studio Art School, Indianapolis, Indiana	
ERNEST MOESSNER, Pupil of Mabel B. Hall, Museum School of Industrial Art, Philadelphia, Pa	
EDWIN E. RISSLAND, Pupil of John R. Grabach, Newark Public School of Fine and Industrial Arts, Newark, N.J. 3 Drawings	
ALLAN MANGOLD, Pupil of William Wiessler, Ohio Mechanics Institute, Cincinnati, Ohio. 28	
CRIS RITTER, Pupil of Richard Lahey, Art Students League, New York City, N.Y30	
EDWARD YATES, Pupil of F. G. Carpenter, St. Louis School of Fine Arts, St. Louis, Mo 31	
VIRGINIA KENNADY, Pupil of Arthur Meltzer, Moore Institute of Art, Science and Industry, Philadelphia School of Design, Philadelphia, Pa	
WILLIAM BECKER, Pupil of Henry G. Keller, Cleveland School of Art, Cleveland, Ohio 33	
EVELYN HARTZOG, Pupil of Olin H. Travis, Art Institute of Dallas, Dallas, Texas	
JOHN GRAMEGNA, Pupil of John R. Grabach, Newark School of Fine and Industrial Arts, Newark, N.J. 3 Drawings	
KATHERINE ROBINSON, Pupil of Ernest Thurn, The Child-Walker School, Boston, Mass 36	
OTTO KEISKER, Pupil of F. G. Carpenter, St. Louis School of Fine Arts, St. Louis, Mo 37,45,74	
PETER E. DENARDO, Pupil of John R. Grabach, Newark School of Fine and Industrial Arts, Newark, N.J	
MIKE OWEN, Pupil of Olin H. Travis, Art Institute of Dallas, Dallas, Texas	
RUSSELL L. PULLEN, Pupil of Kreigh Collins and Alexander Flynn, David Walcott Kendal Memorial Art School, Grand Rapids, Michigan	
HORACE DAUGHTERS, Pupil of William E. Wiessler, Ohio Mechanics Institute, Cincinnati, Ohio	
DUANEW. JOHNSON, National Academy of Design, New York City, N.Y43	
HARRY R. ALLEN, Pupil of Myron B. Chapin, College of Architecture, University of Michigan, Ann Arbor, Michigan	
THELMA GRAHAM, Pupil of M'Cullough Partee, Watkins Institute, Nashville, Tenn Left 46	
GEROME KAMROWSKI, Pupil of Cameron Booth, St. Paul School of Art, St. Paul, Minn	
CAROLINE JONES, Pupil of Edmund Greacen, Grand Central School of Art, New York City, N.Y	
HOMMER DUNN, Pupil of Elmer E. Taflinger, Elmer E. Taflinger Studio Art School, Indianapolis, Indiana	
ED. NOFZIGER, Pupil of Mrs. Beryl Smith, University of California at Los Angeles Top 50	

EDNA SCHMIDLER, Department of Art, Washburn College, Topeka, Kansas Top 50
PAULINE HIRST, Pupil of Beryl K. Smith, Art Department, University of California, Los Angeles, Calif
GEORGE NIGHTINGALE, Pupil of Wilber Stilwell, Emporia School of Art, Emporia, Kansas
BEATA BEACH, Pupil of Richard Lahey, Art Students League, New York City, N.Y
MARY L. KESSBERGER, Pupil of Alexander Mustro-Valerio, University of Michigan, Ann Arbor, Michigan
HELEN BATCHELOR, Pupil of Elmer E. Taflinger, Elmer E. Taflinger Studio Art School, Indianapolis, Indiana
GENE GUERNSEY, Pupil of R. McLellan, School of Industrial Art, Philadelphia, Pa55
NAOMI FITCH, Pupil of Byron G. Culver, Dept. of Applied Art, Mechanics Institute, Rochester, N.Y
MARGARET HOLT, Pupil of Doel Reed, Oklahoma A. & M. College, Stillwater, Oklahoma
S. H. RICHARDSON, Pupil of John Lyon Reid, Mass. Institute Technology, Boston, Mass 57
HARRY DAVIS, Pupil of H. Mayer, John Herron Art Institute, Indianapolis, Ind
PAUL BRADFORD, Pupil of Sudduth Goff, American Academy of Art, Chicago, Ill Left 59
LAWRENCE G. LOW, Pupil of Elmer W. Greene, Jr., Designers Art School, Boston, Mass
Right 59
PAUL GRAHAM, Pupil of William Wiessler, Ohio Mechanics Institute, Cincinnati, Ohio Top 60
MARVIN D. CHURCH, Pupil of Sudduth Goff, American Academy of Art, Chicago, III Lower 60
GILBERT GAW, Pupil of Fred G. Gray, American Academy of Art, Chicago, III Top left 61
W. B. PETZOLD, Pupil of Sudduth Goff, American Academy of Art, Chicago, III Top right 61
MIRIAM TROOP, Pupil of Arthur Meltzer, Institute of Art, Science & Industry, Philadelphia School of Design, Philadelphia, Pa
LINCOLN L. CIAMPA, Pupil of Elmer W. Greene, Jr., Designers Art School, Boston, Mass Right 62
CECILIE SCHRAMM, Pupil of George B. Bridgman, Art Students League, New York City, N.Y.
JOHN BURDA, Pupil of F. G. Carpenter, St. Louis School of Fine Arts, St. Louis, Mo. 2 Drawings
TAD BAILEY, Pupil of A. Iacovleff, School of the Museum of Fine Arts, Boston, Mass 65
IOHN A. RUGE, Pupil of George B. Bridgman, Art Students League, New York City, N.Y 66

HELEN F. COLLINSON, Pupil of S. Burtis Baker, Corcoran School of Art, Washington, D.C. 67
RALPH W. LERMOND, Pupil of A. lacovleff, School of the Museum of Fine Arts, Boston, Mass.
J.T. SPEARMAN, Pupil of Roy H. Staples, The Alabama Polytechnic Institute, Auburn, Ala Left 69
ISABEL B. JAMISON, Pupil of Edmund Greacen, Grand Central School of Art, New York City, N.Y
J. B. WANDERSFORDE, University of Washington, Seattle, Wash
SARAH TAYLOR, Pupil of Charles Wilimovsky, American Academy of Art, Chicago, Ill. Right 72
MARGARET CULVER, Pupil of Alexander Mastro-Valerio, College of Architecture, University of Michigan, Ann Arbor, Michigan
WILLIAM PEED, Pupil of H. Mayer, John Herron Art Institute, Indianapolis, Ind
HARRIETTE GILBERT, Pupil of Frank M. Rines, Cambridge School of Architecture and Landscape Architecture, Cambridge, Mass
THOMAS YAMO, Pupil of George Harding, School of Fine Arts, University of Pennsylvania, Philadelphia, PaLeft 77
DONALD HAWLEY, Pupil of George B. Bridgman, Art Students League, New York City, N.Y.
MARGARET HOLT, Pupil of Doel Reed, Oklahoma A. & M. College, Department of Art, Stillwater, Okla
KATERINE SAMPSON, Pupil of Arthur Meltzer, Moore Institute of Art, Science and Industry, Philadelphia School of Design, Philadelphia, Pa
MERRENDA SHELDAHL, Pupil of Alice McKee Cumming, Cumming School of Art, Des Moines, Iowa
MARION M.VAN EVERY, Pupil of Jean Paul Slusser, University of Michigan, College of Architecture, Ann Arbor, MichLeft 81
WILLIAM JUSTICE, Pupil of H. Mayer, John Herron Art Institute, Indianapolis, Ind Right 81
CLIFFORD N. GEARY, Pupil of Frank M. Rines, Cambridge School of Architecture and Landscape Architecture, Cambridge, MassLeft 84
A. WARD GARDNER, Pupil of Ralph McLellan, School of Industrial Art, Philadelphia, Pa
Right 84
ELON H. CLARK, Pupil of Alling M. Clements, School of Applied Art, Mechanics Institute, Rochester, N.Y
JEANNETTE D. JOHNSON, Pupil of William H. Giuler, School of the Portland Art Museum, Portland, OreLeft 86
H. P. CROSS, Pupil of John Lyon Reid, Mass. Institute of Technology, Boston, Mass. Right top 86

KLETH BLAKE, Pupil of Doel Reed, Oklahoma A. & M. College, Stillwater, Okla Top right 88
LAWRENCE W. HALL, Douglas, Wyoming, School of Applied Art Left-below 88
CHARLES W. BURROUGHS, Pupil of Jean Paul Slusser, College of Architecture, University of Michigan, Ann Arbor, MichLeft 89
ALVIN MERRITT, Pupil of Byron G. Culver, Department of Applied Art, Mechanics Institute Rochester, N.Y
JOHN TEYRAL, Pupil of A. lacovleff, School of the Museum of Fine Arts, Boston, Mass 90
DARRELL BROWN, Pupil of Alice McKee Cumming, Cumming School of Art, Des Moines Iowa Left 91
ABBOTT CHEEVER, Pupil of A. lacovleff, School of the Museum of Fine Arts, Boston, Mass. 92
G. J. SOETE, Pupil of William Wiessler, Ohio Mechanics Institute, Cincinnati, Ohio
R. HELEN SCHORR, Pupil of William Wiessler, Ohio Mechanics Institute, Cincinnati, Ohio . 95

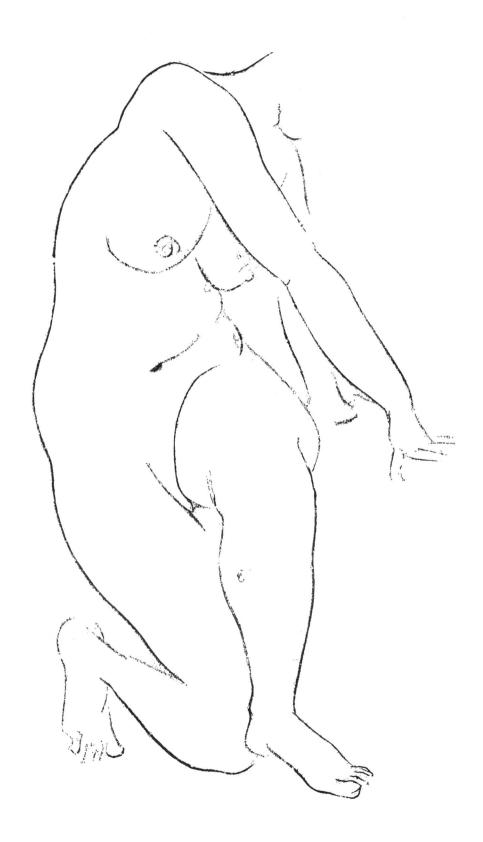

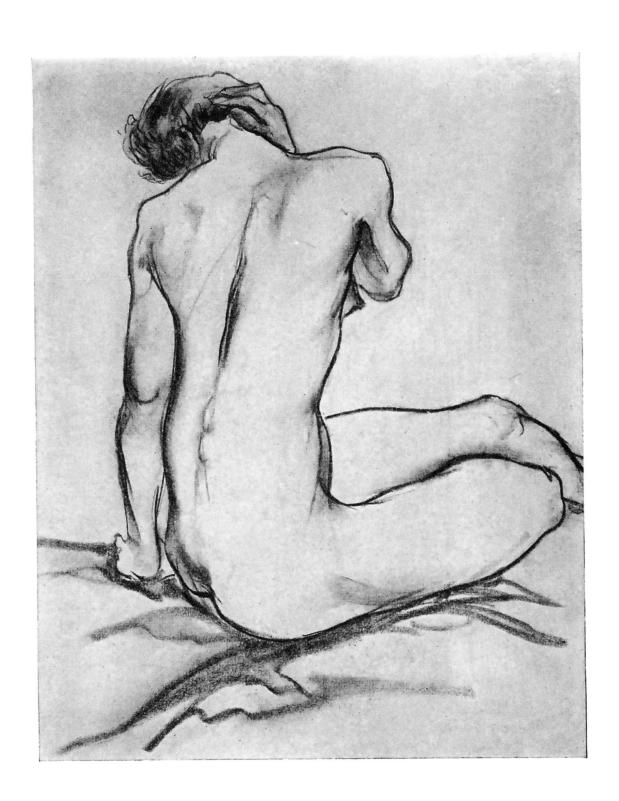

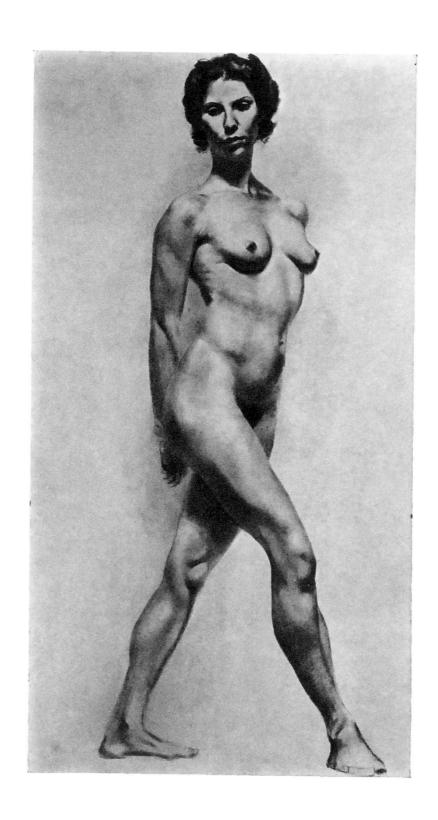

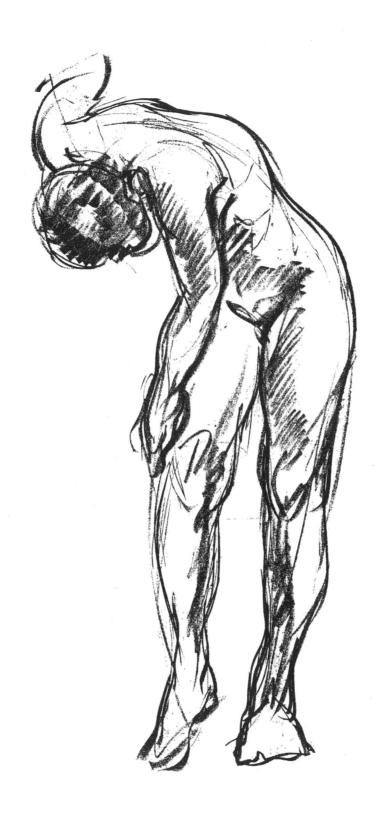

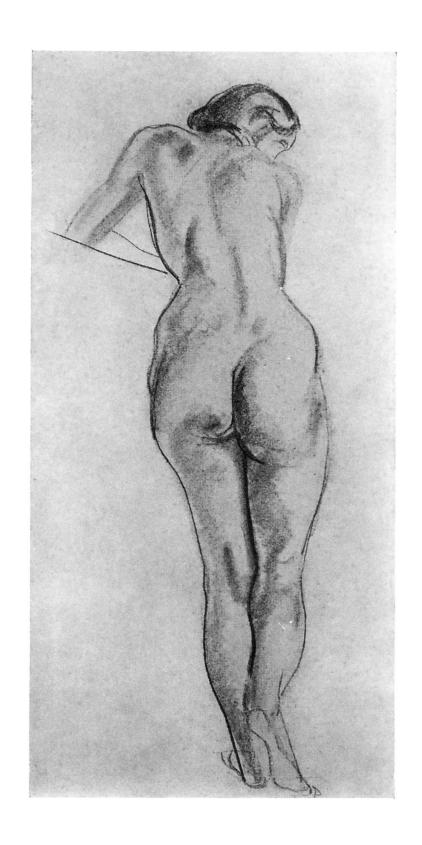

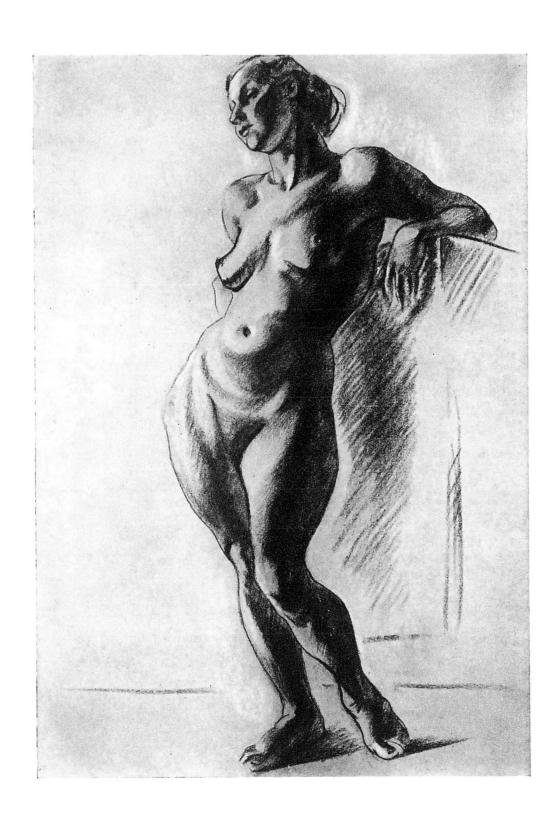

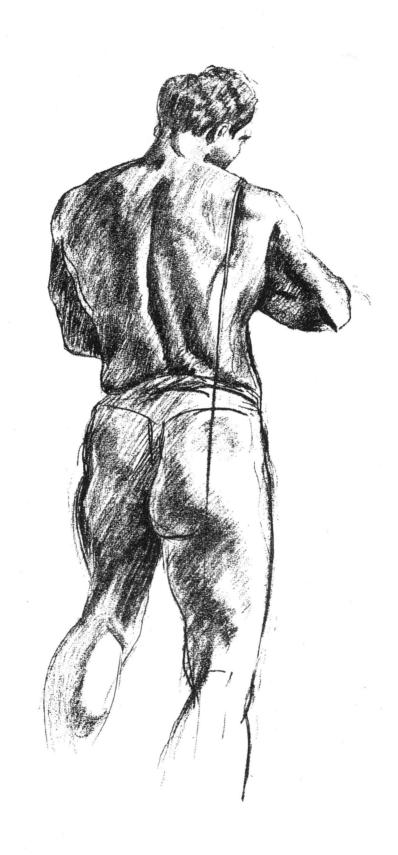

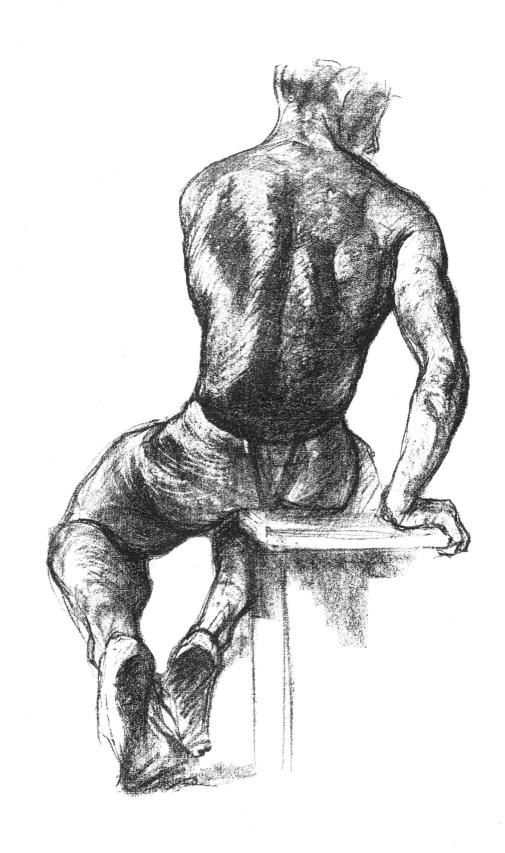

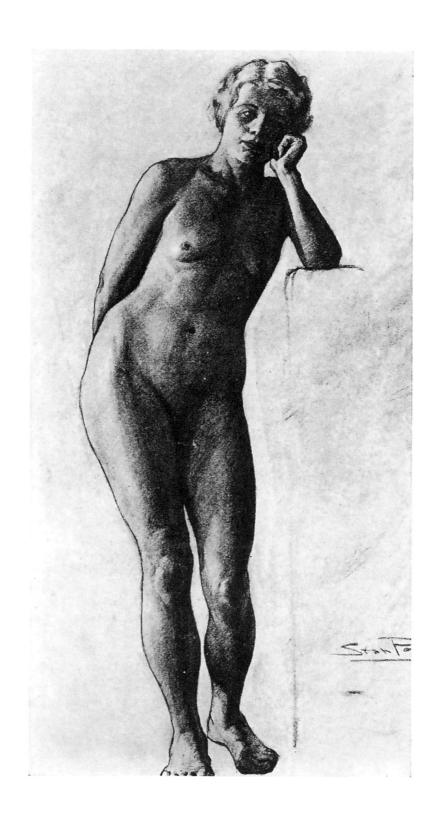

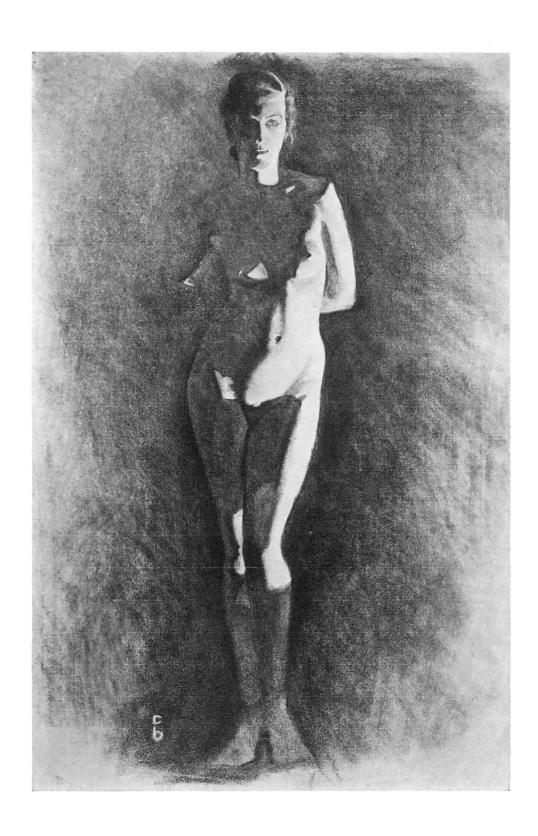

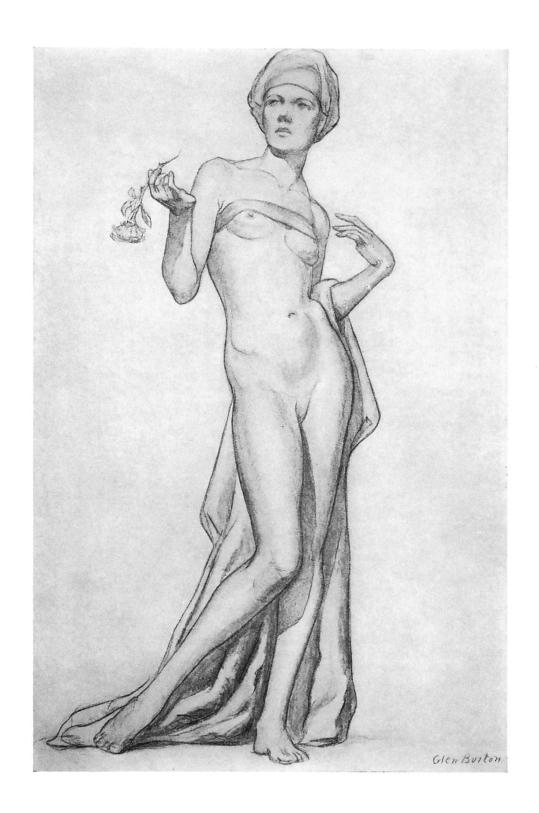

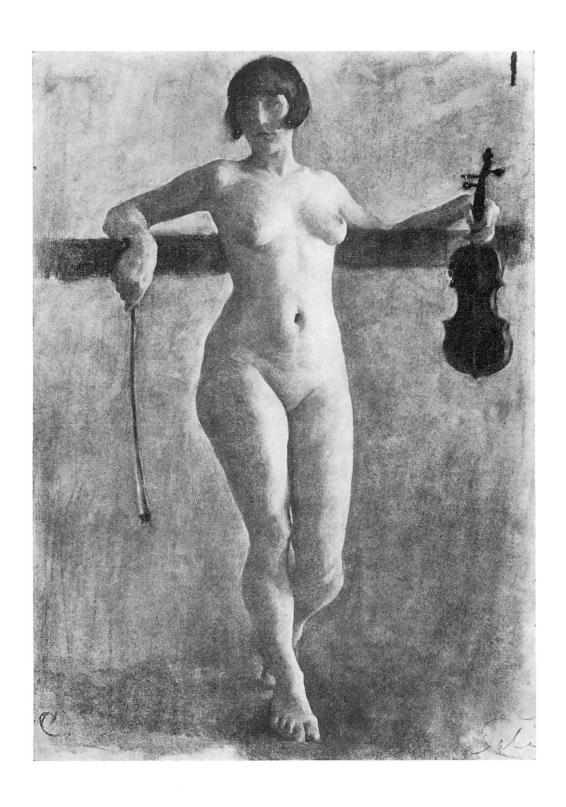

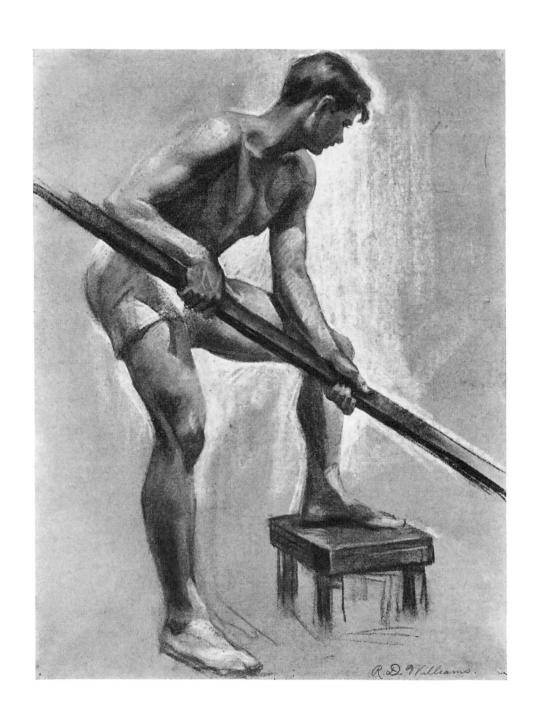

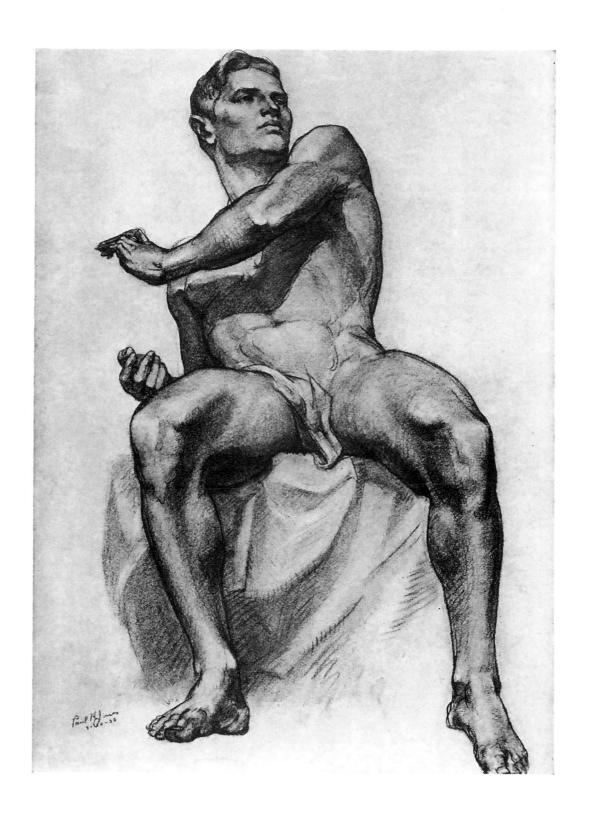

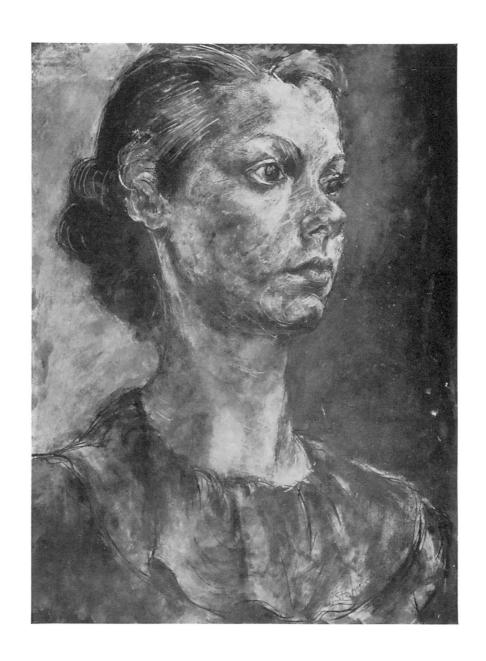

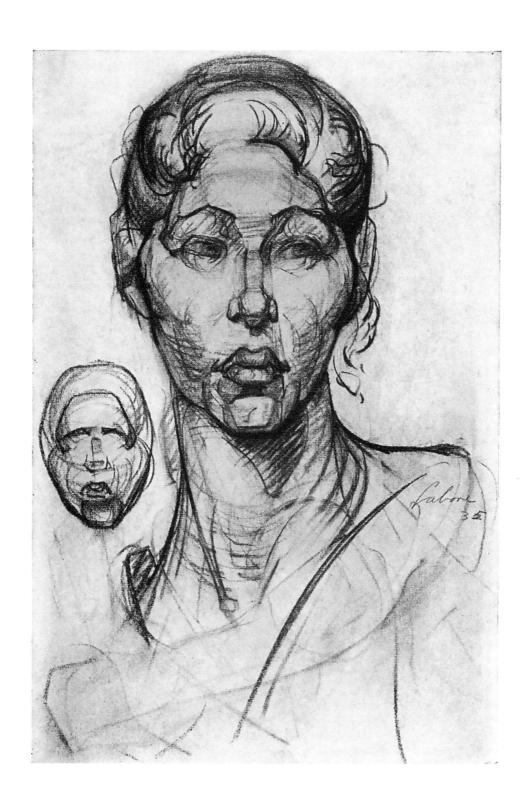

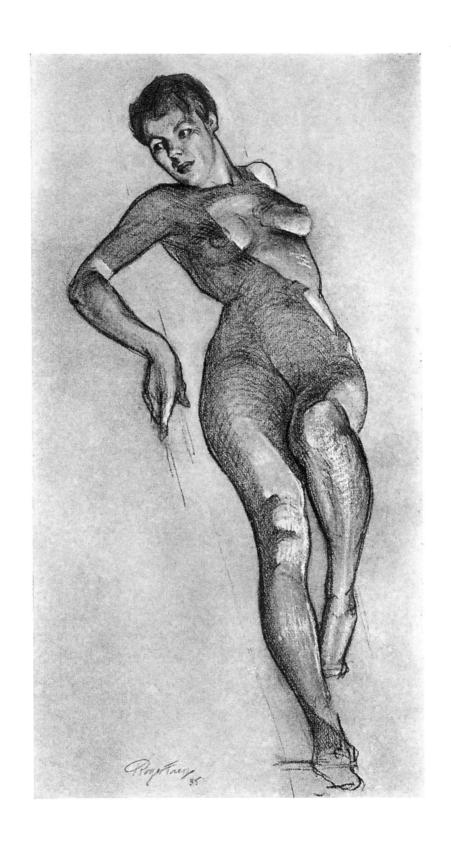

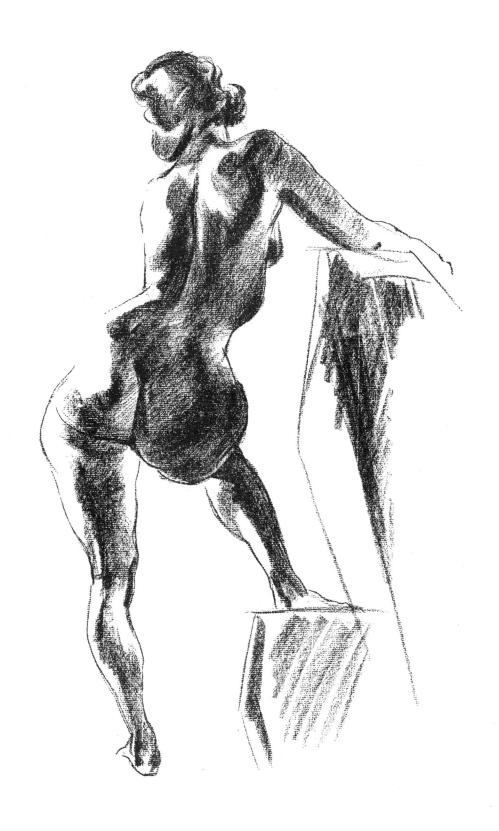

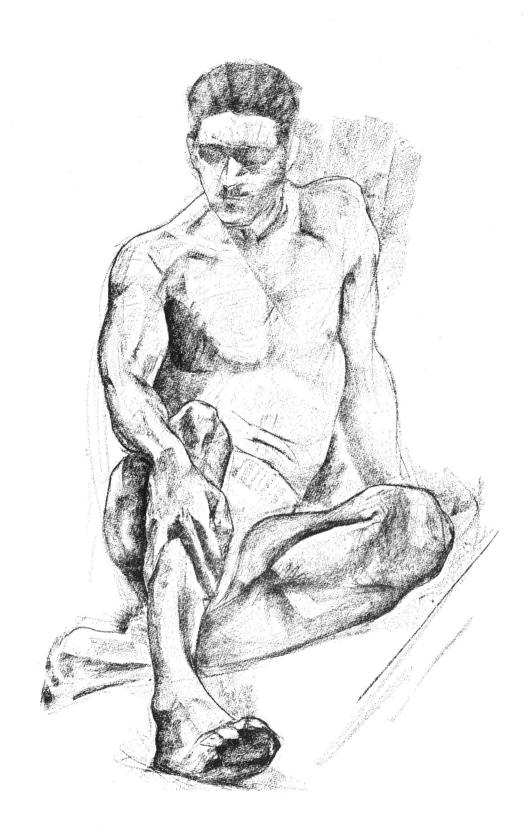

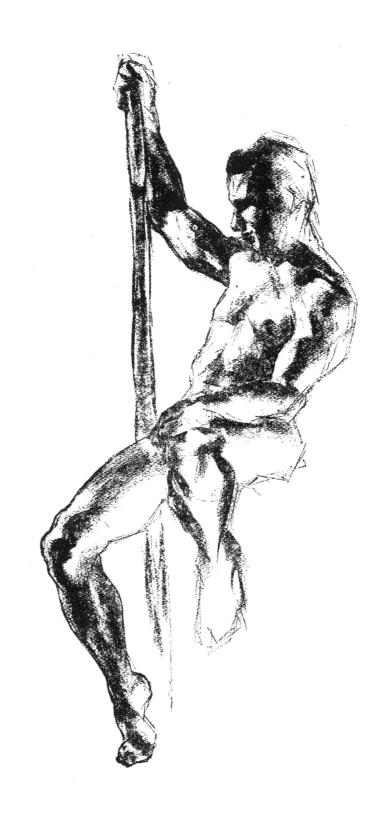

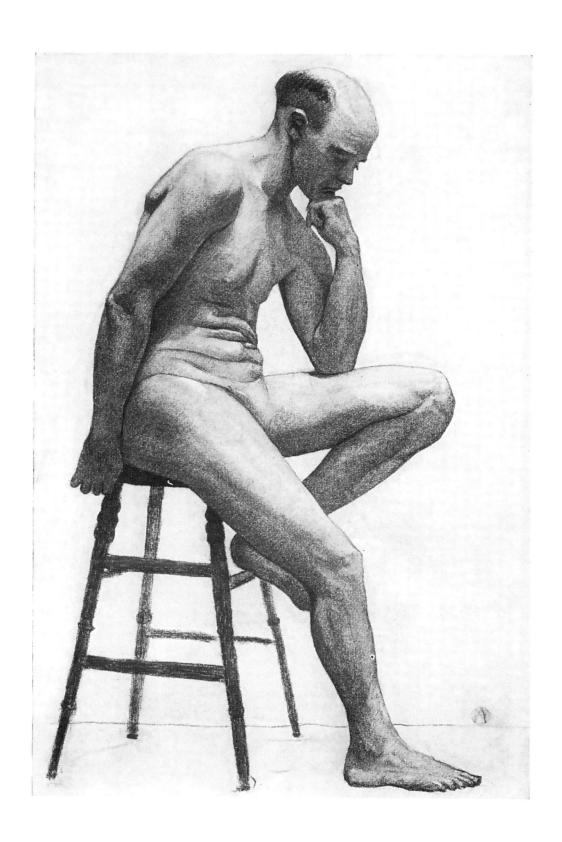

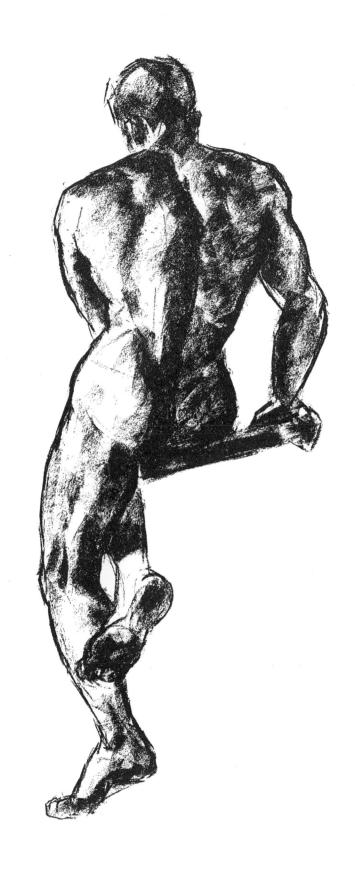

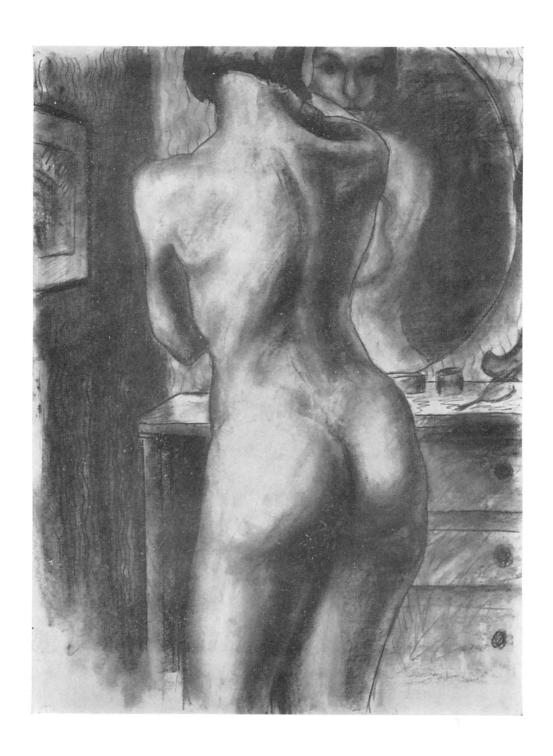

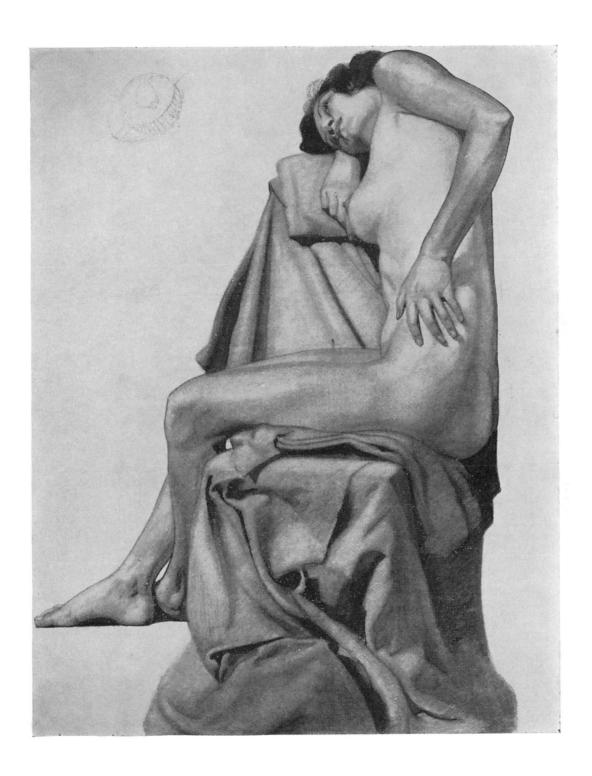

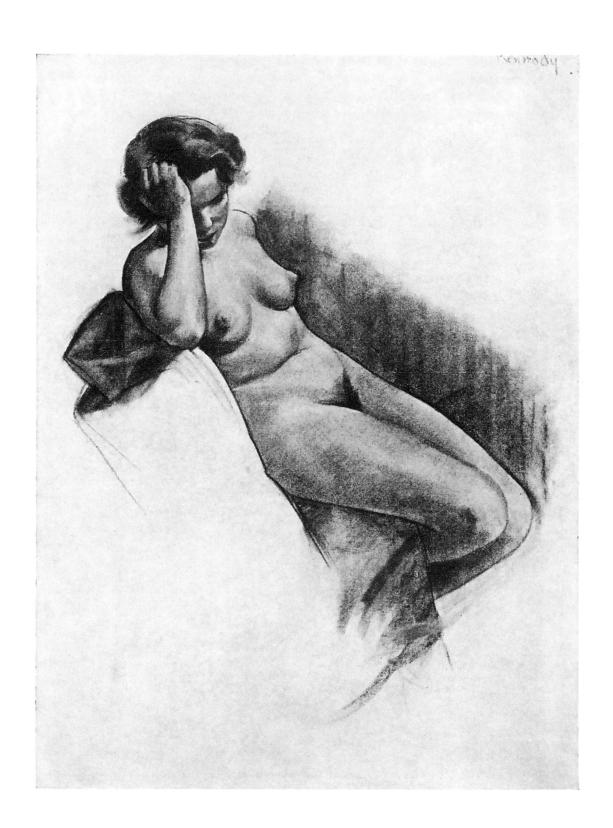

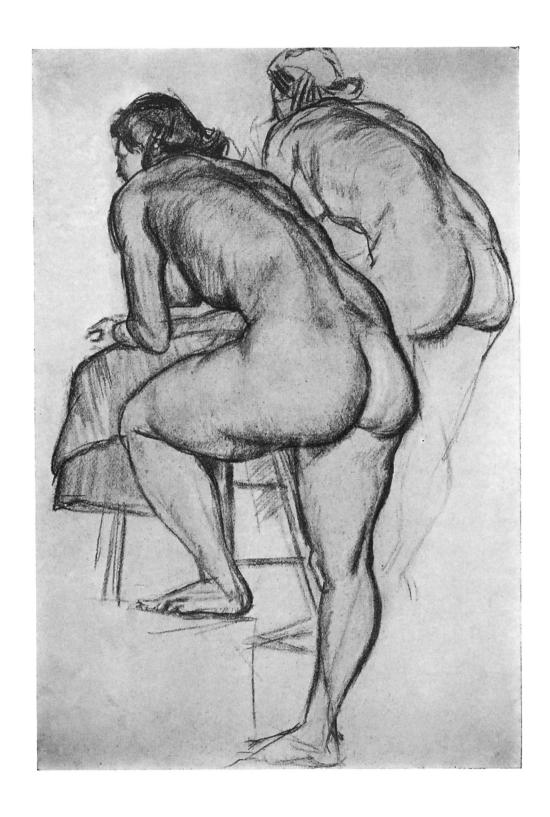

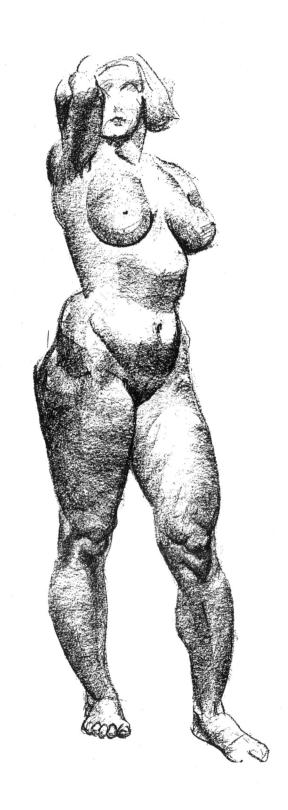

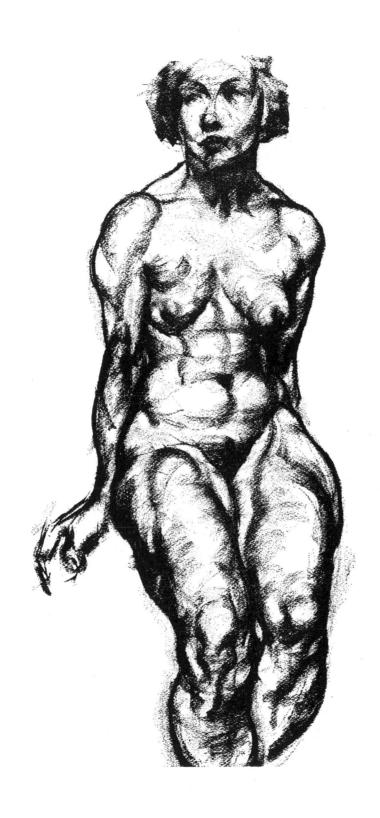

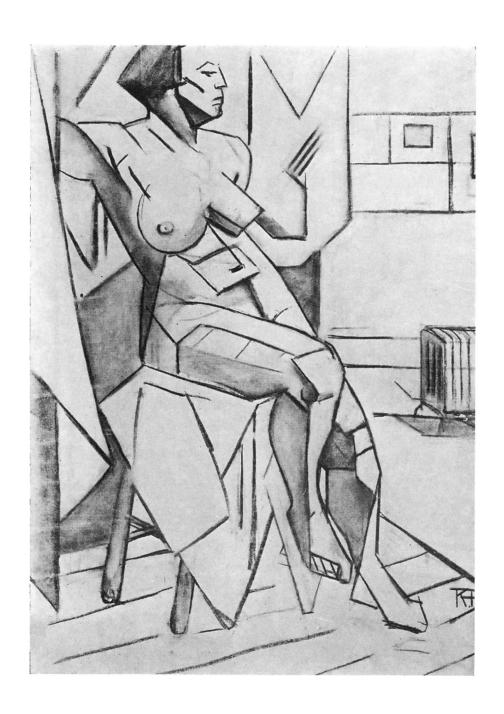

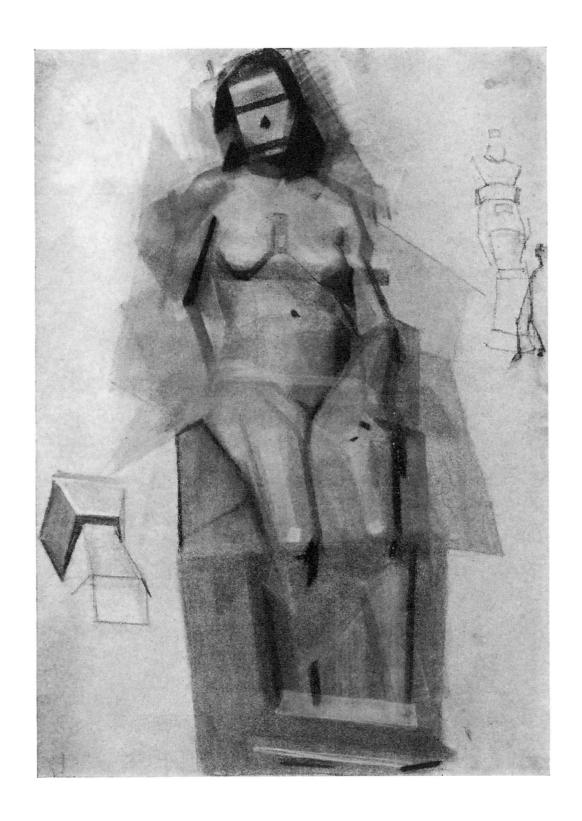

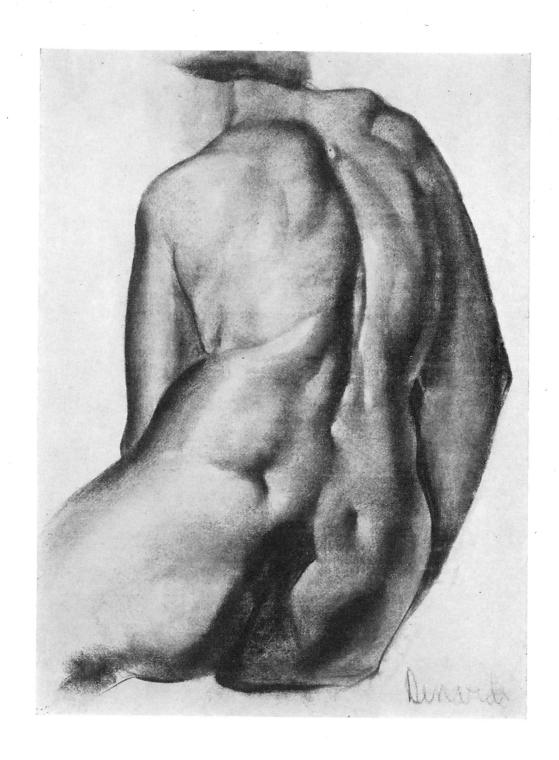

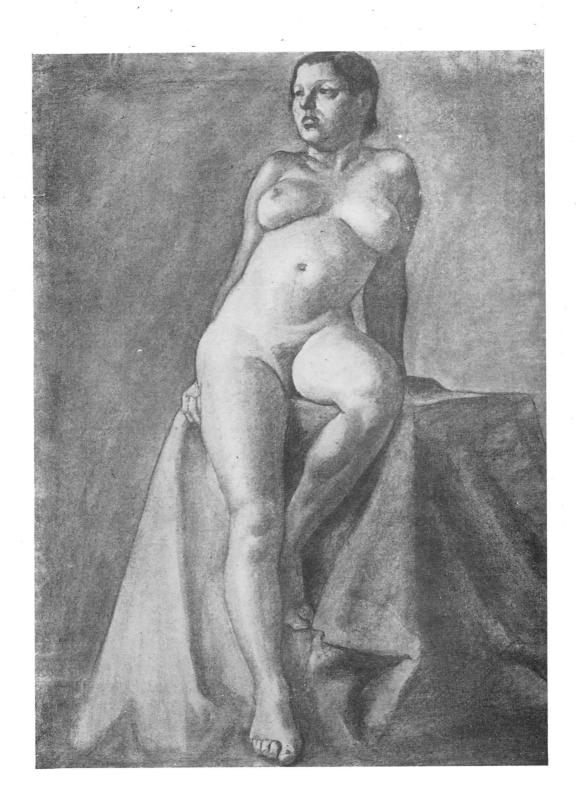

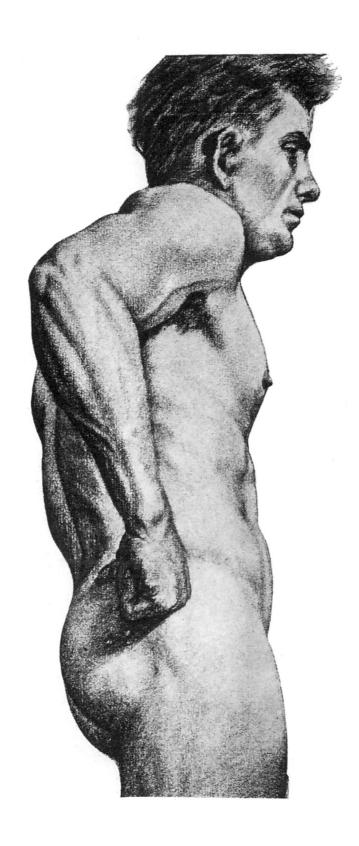

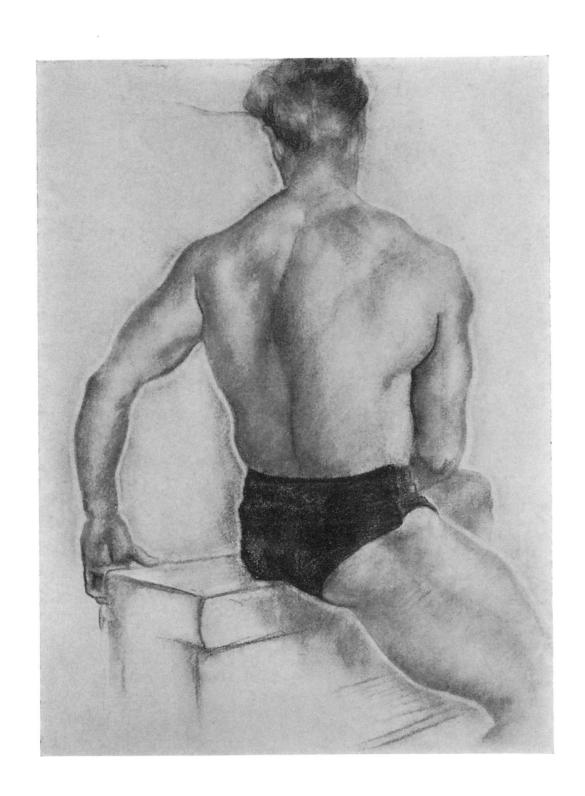

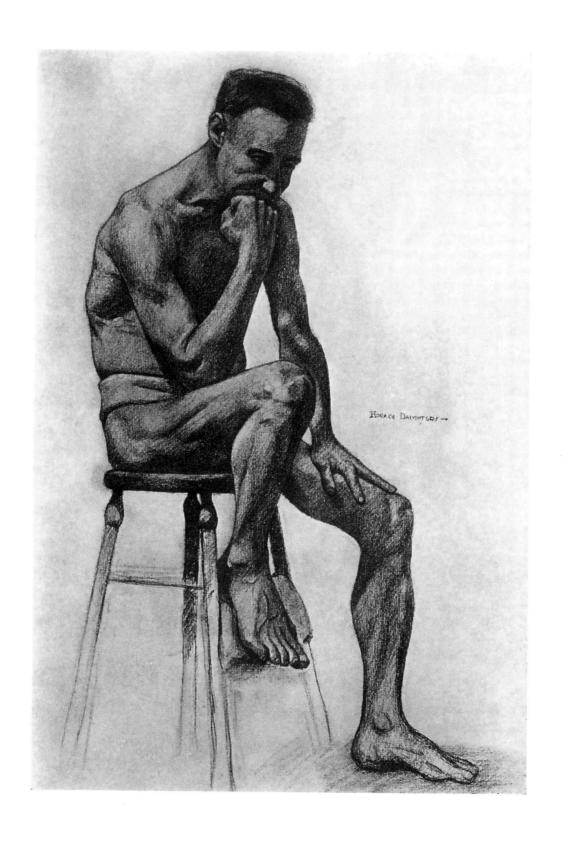

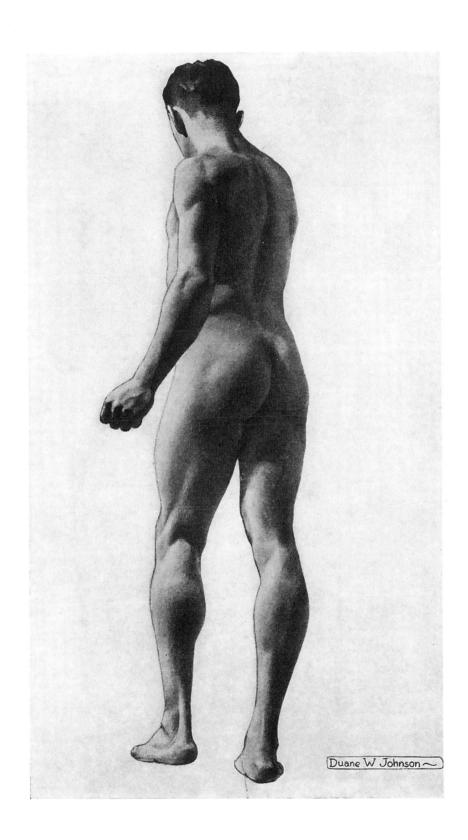

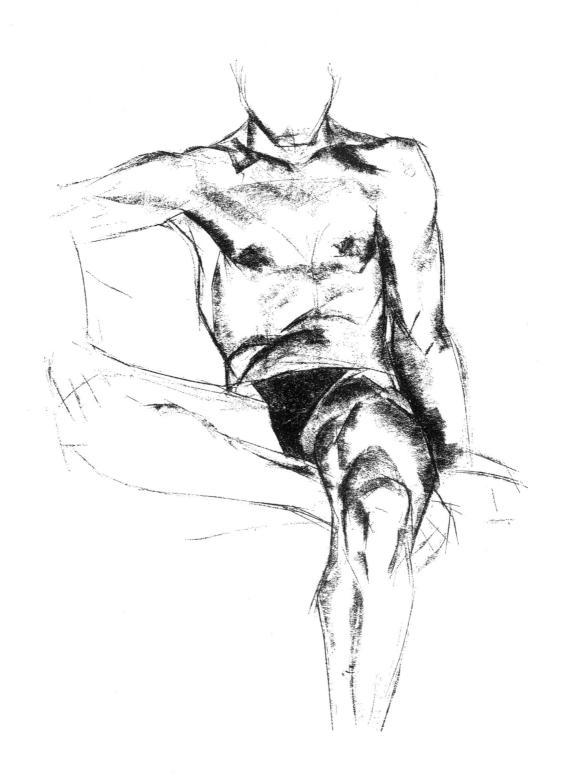

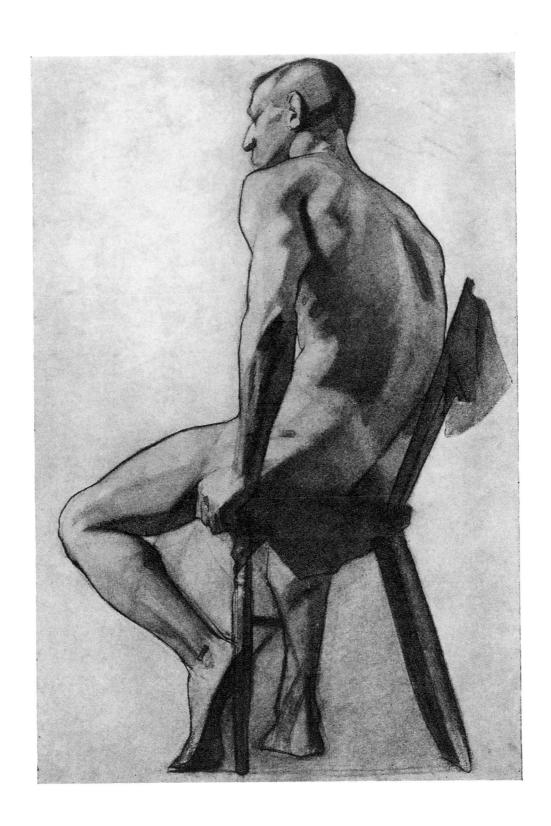

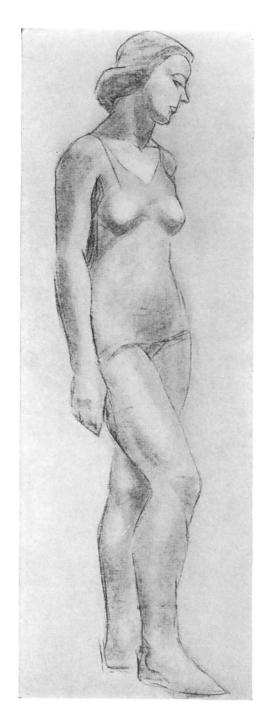

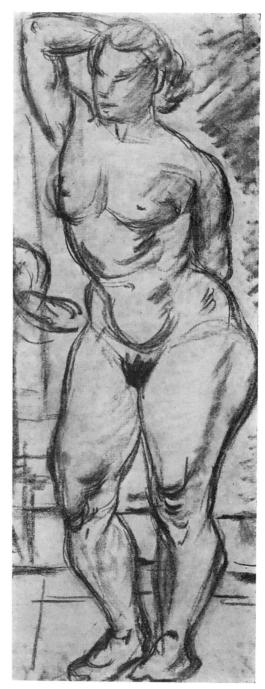

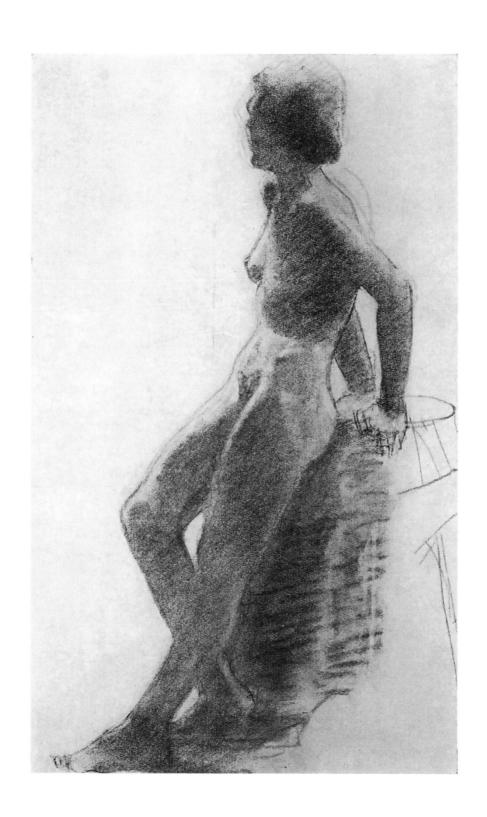

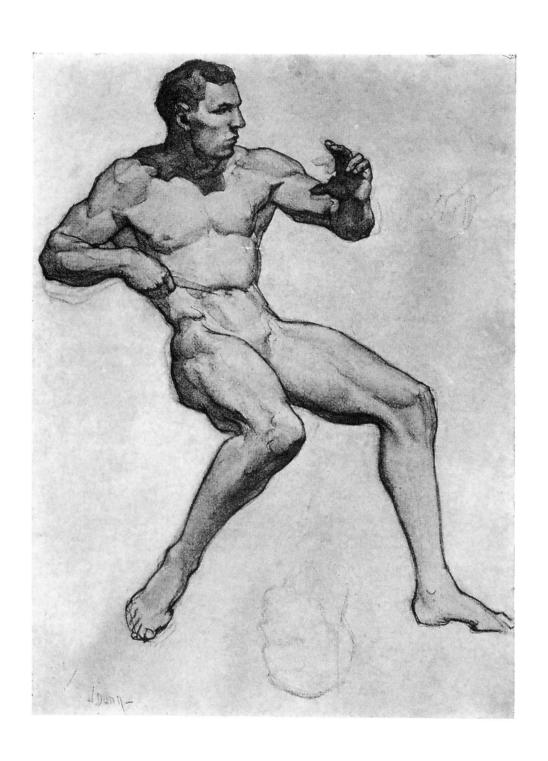

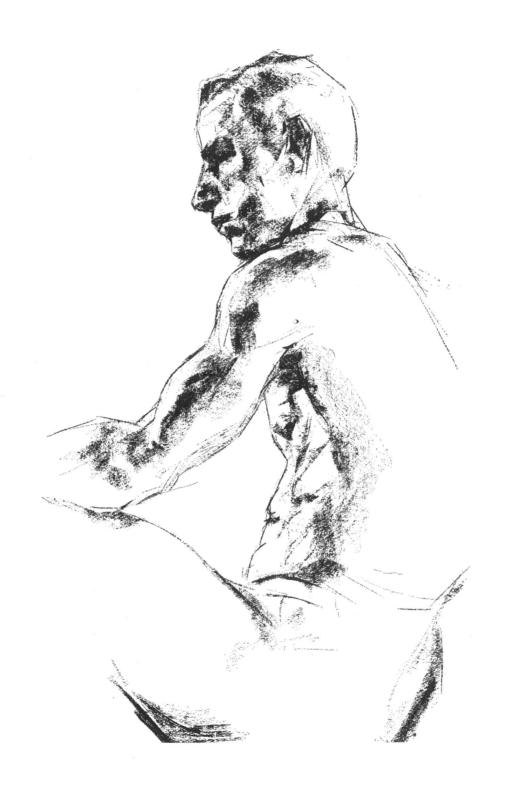

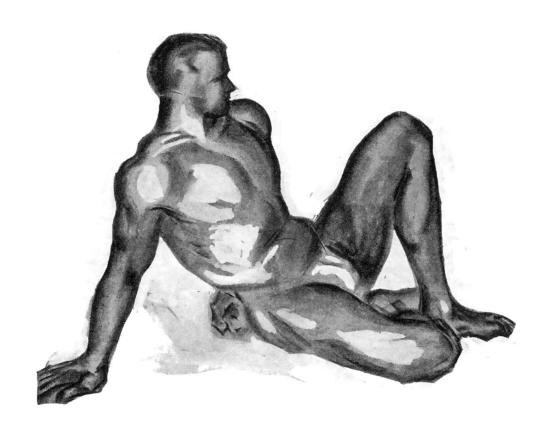

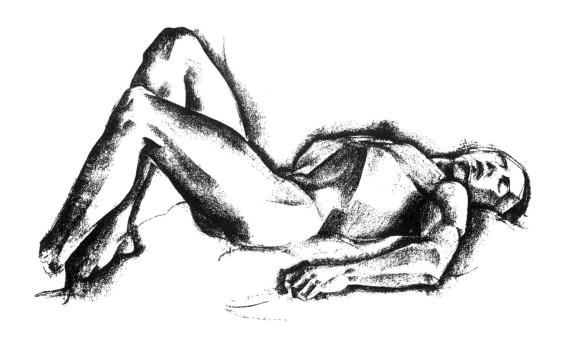

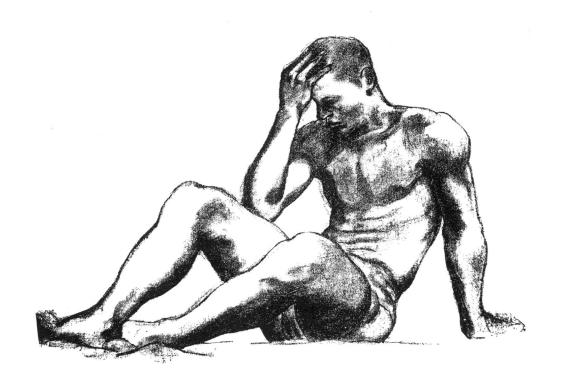

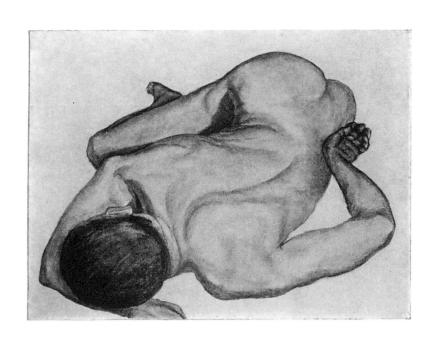

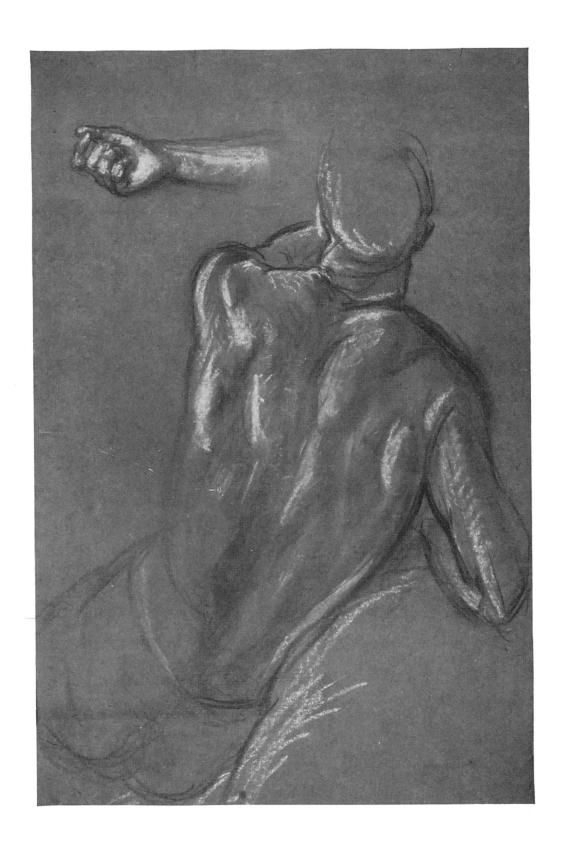

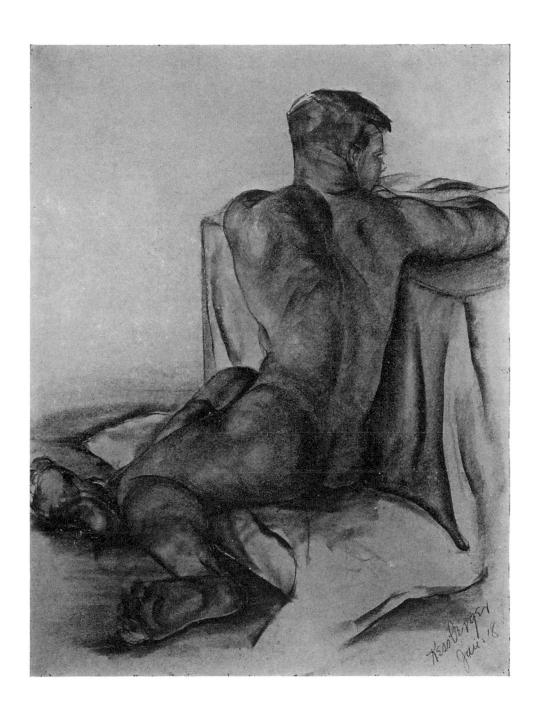

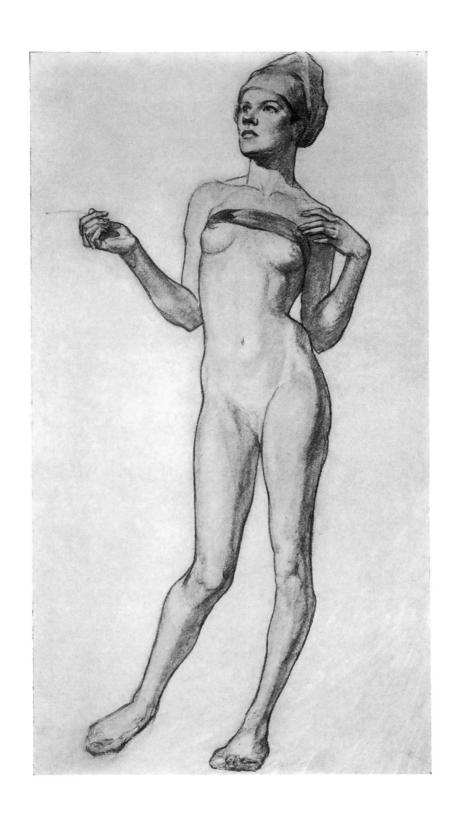

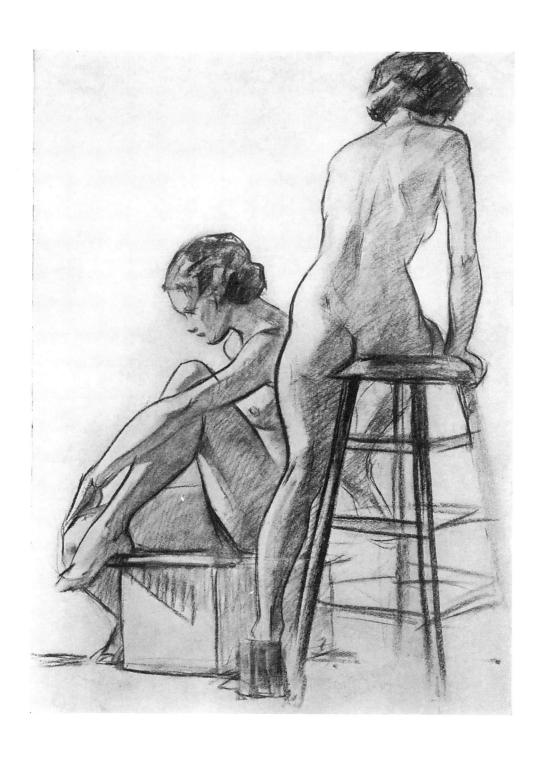

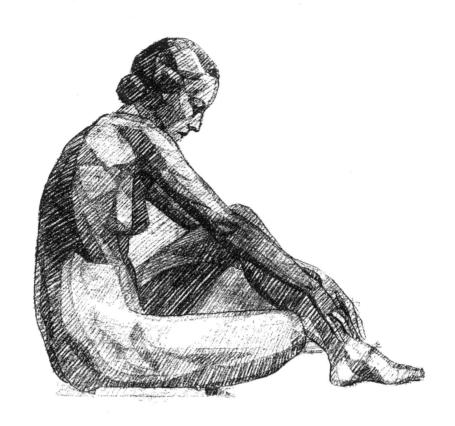

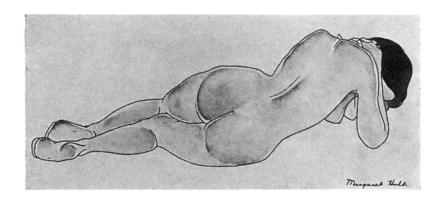

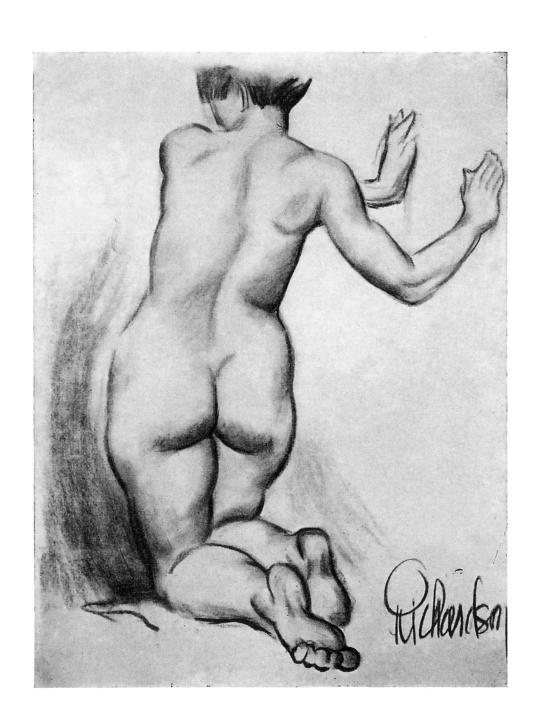

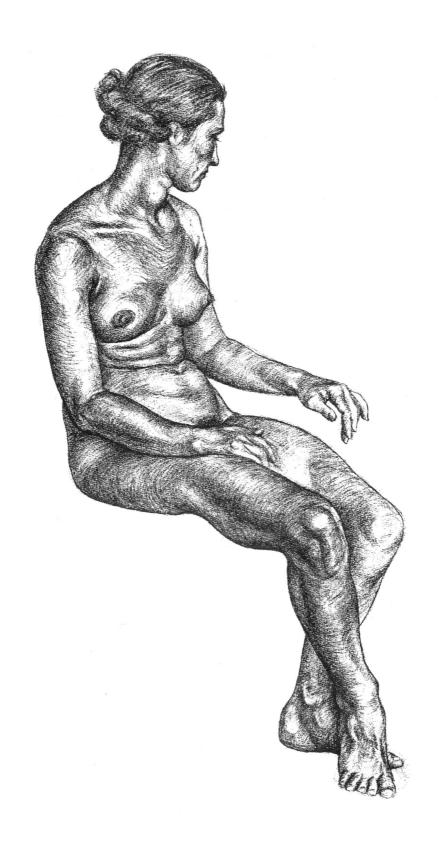

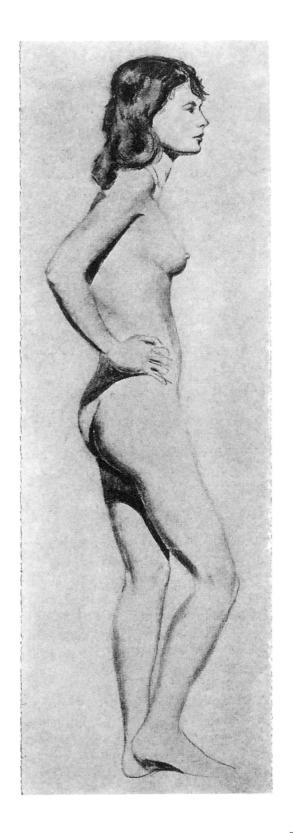

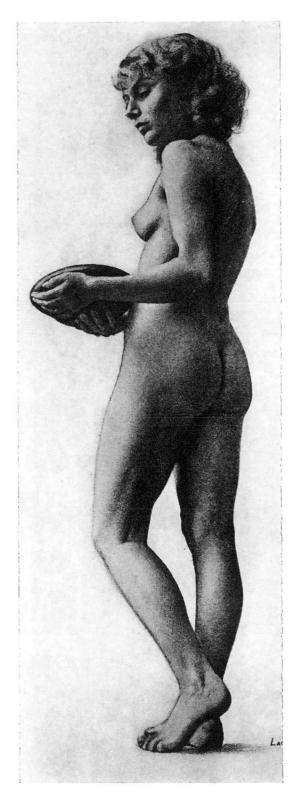

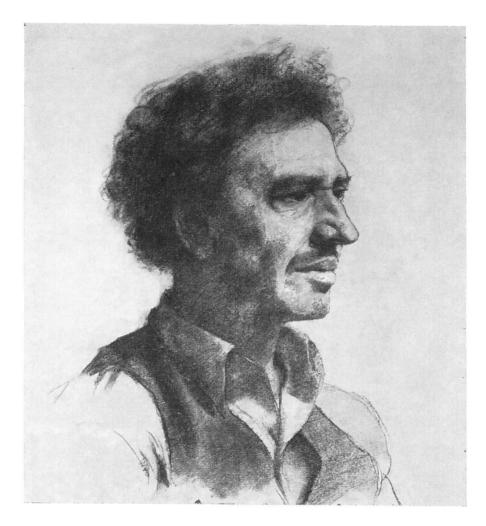

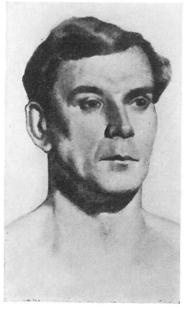

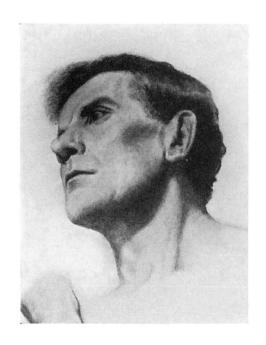

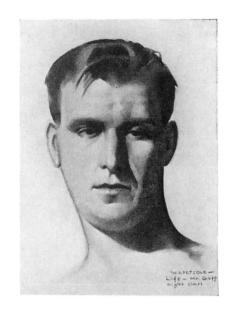

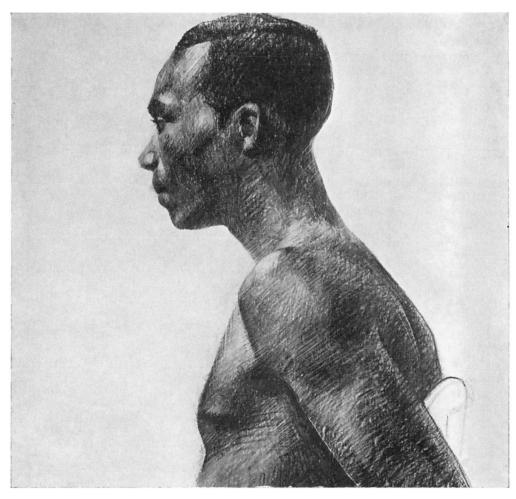

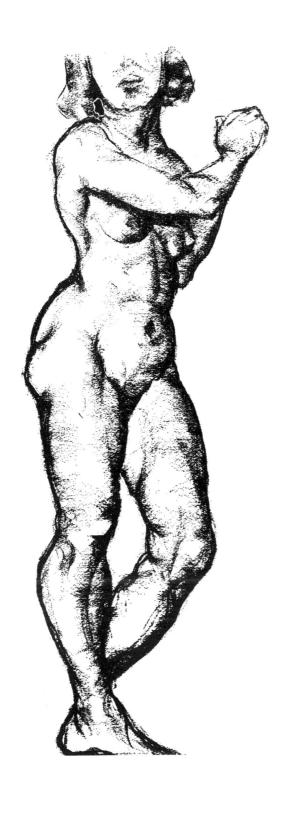

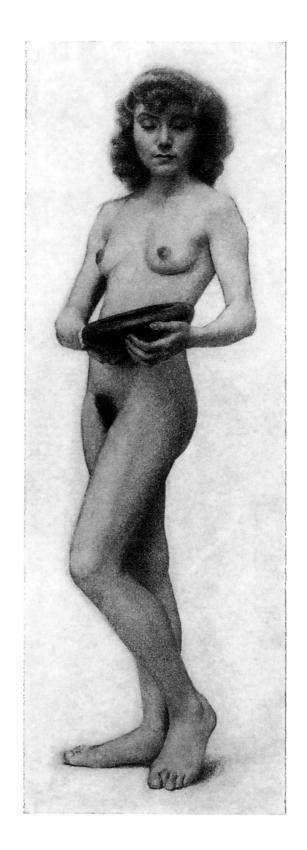

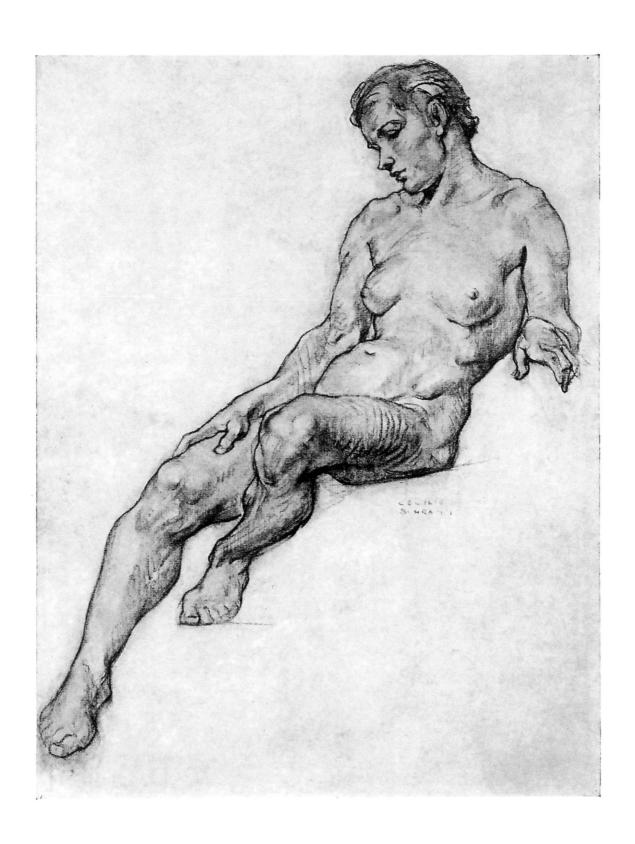

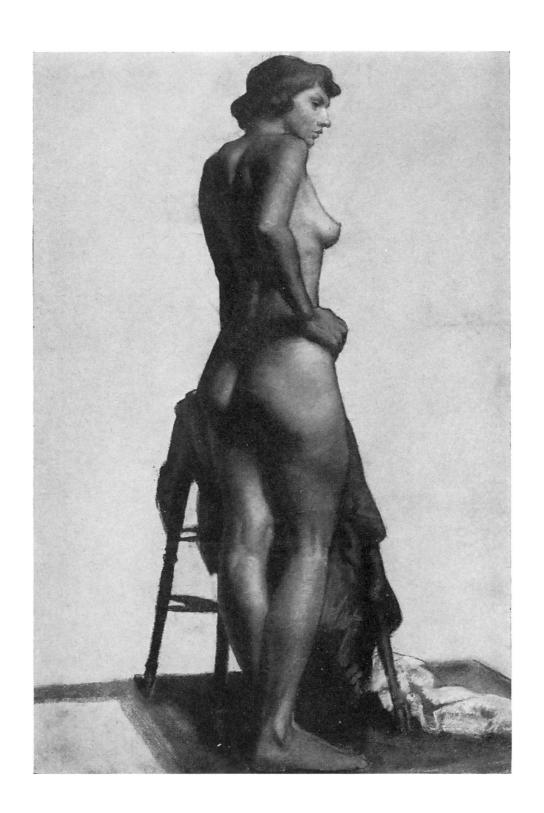

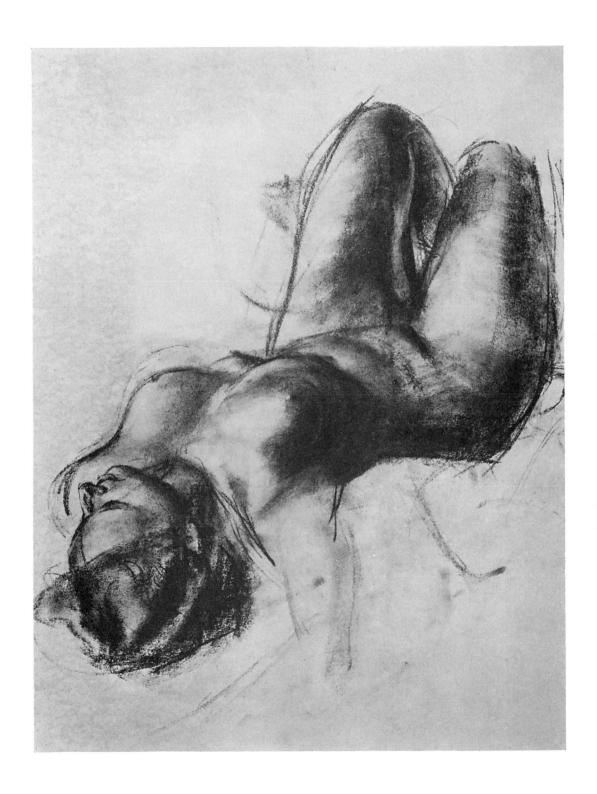

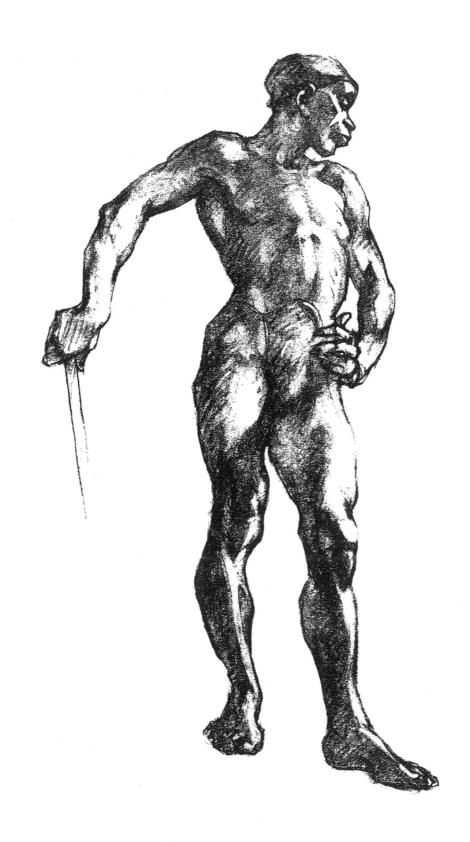

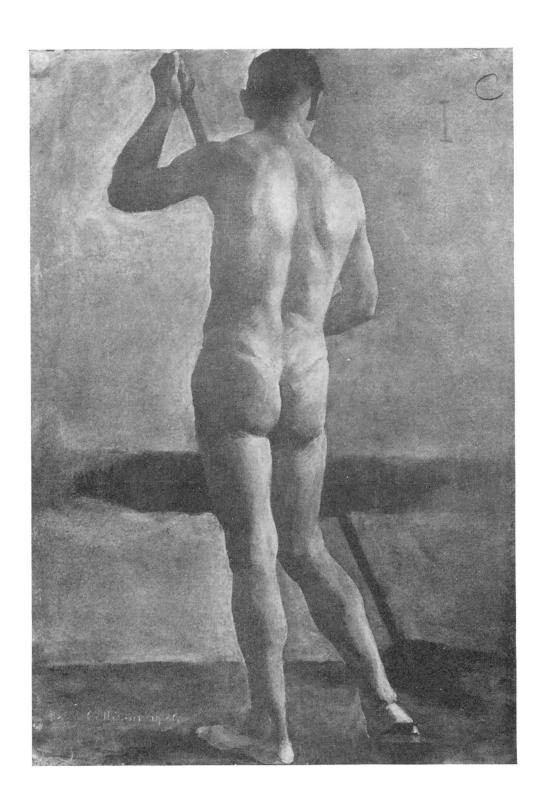

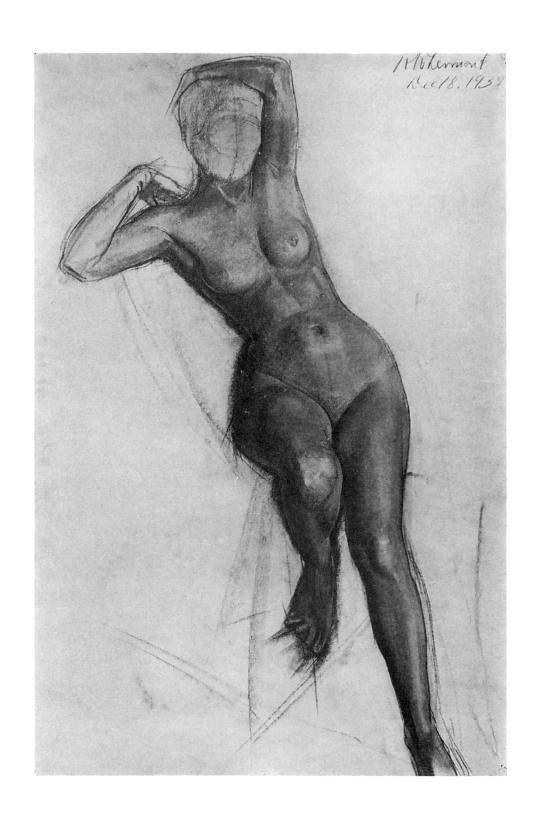

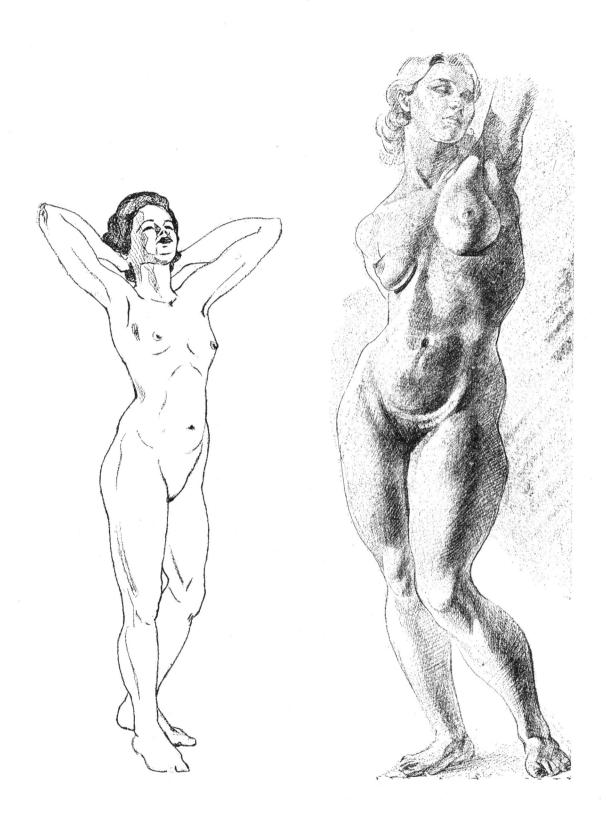

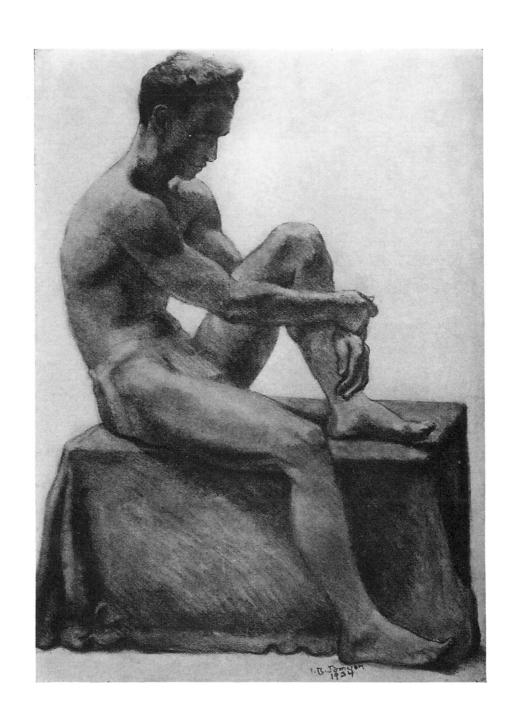

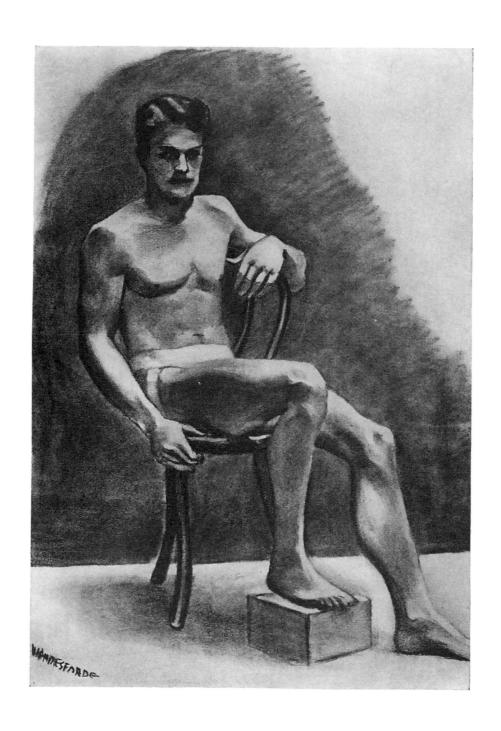

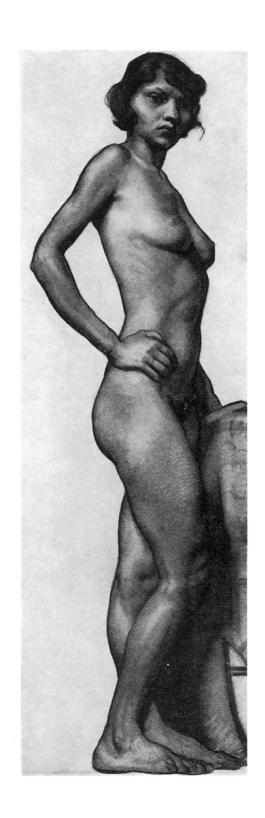

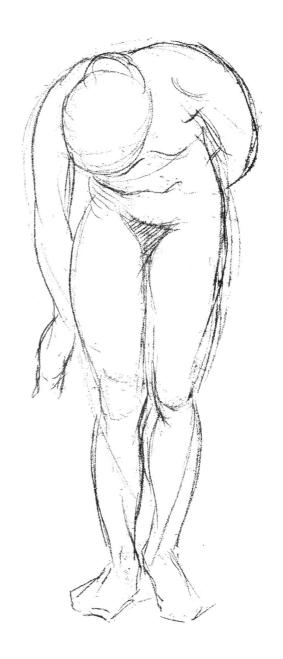

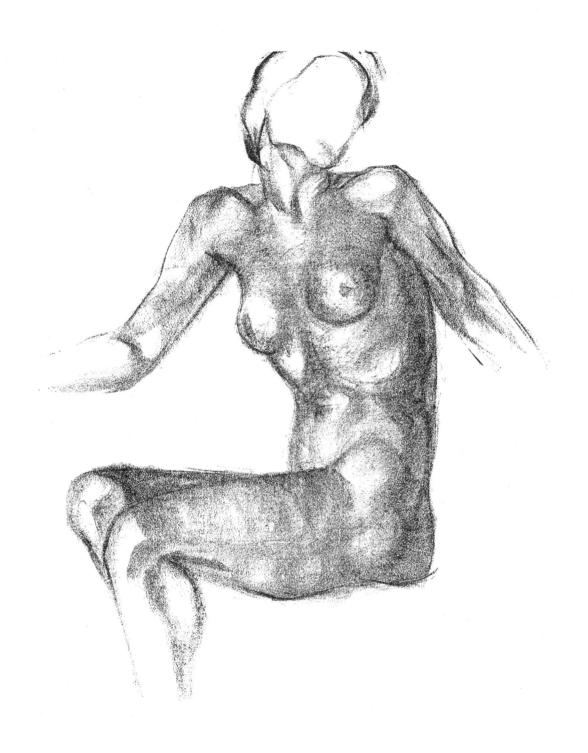

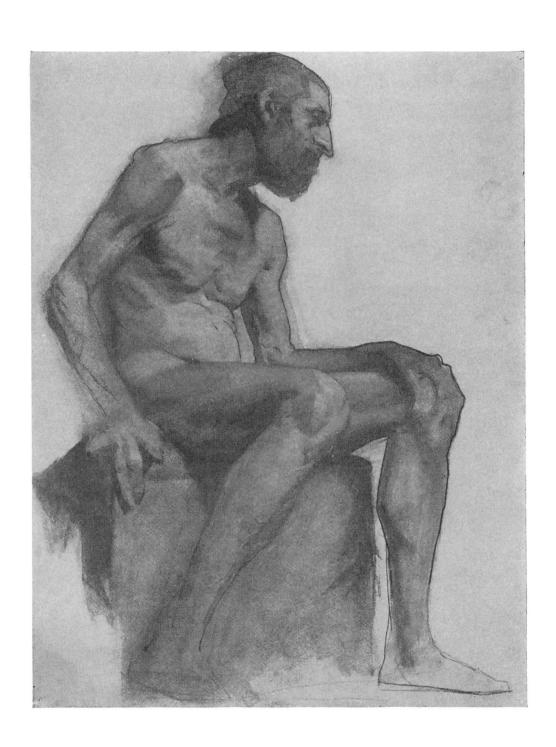

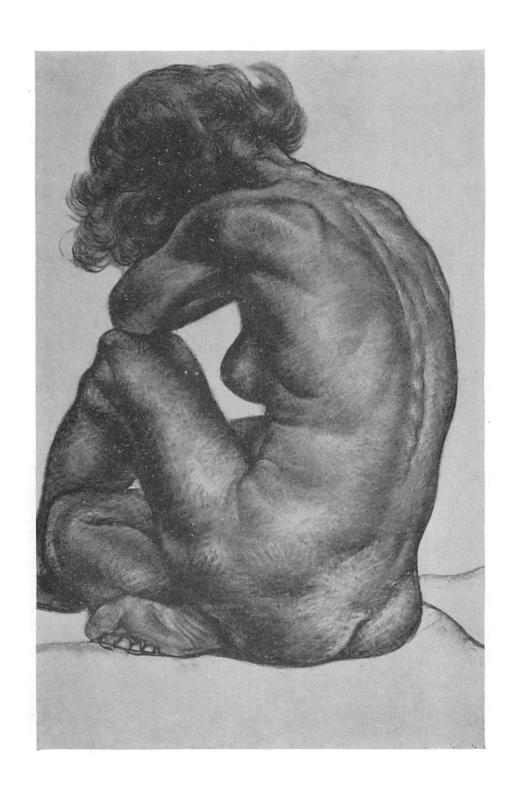

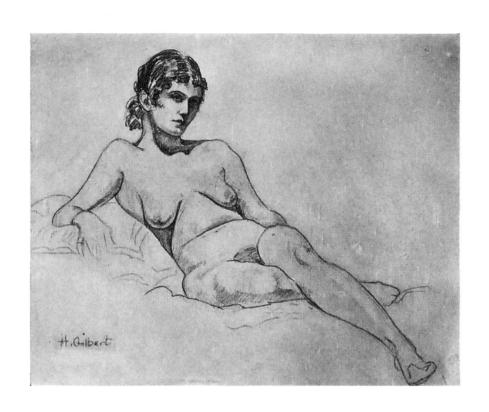

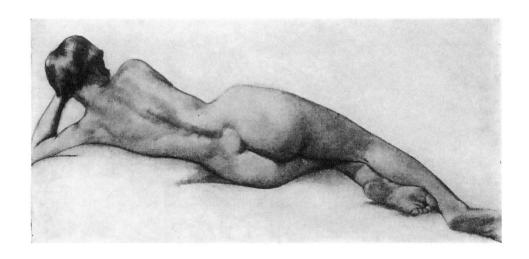

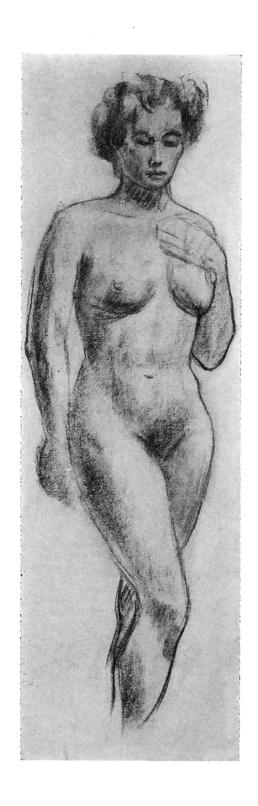

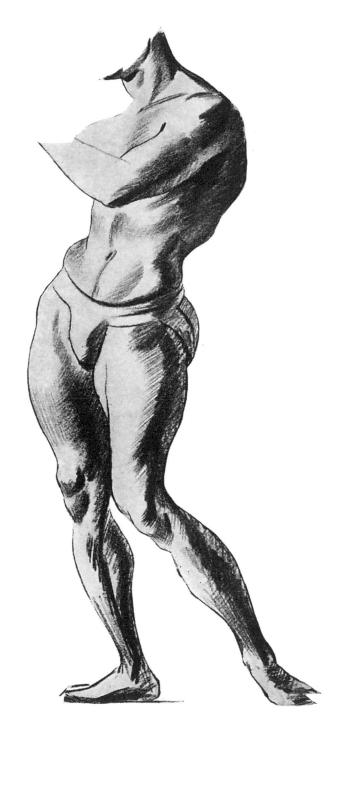

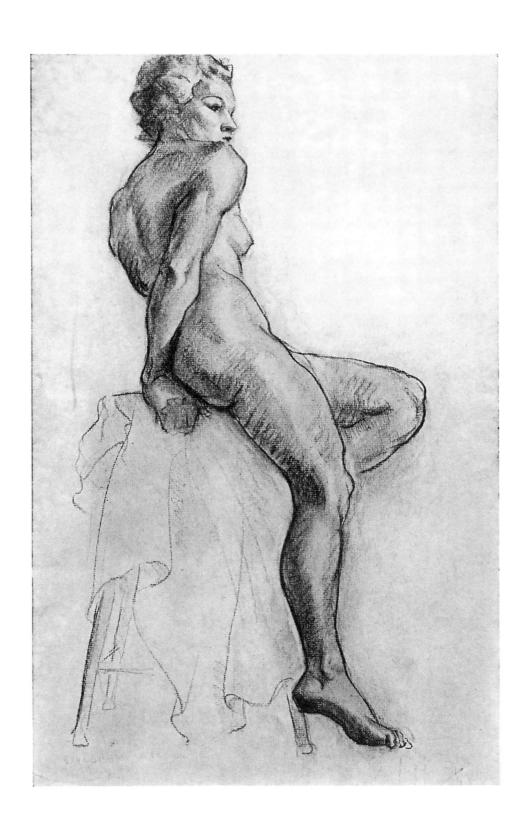

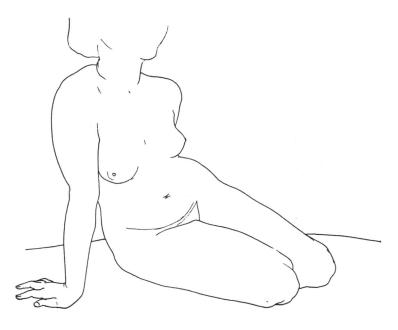

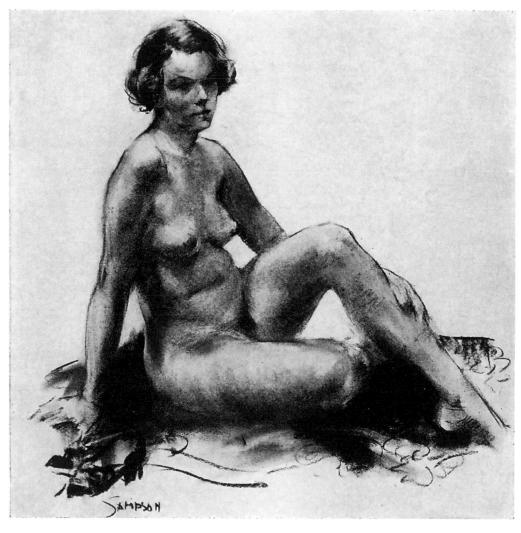

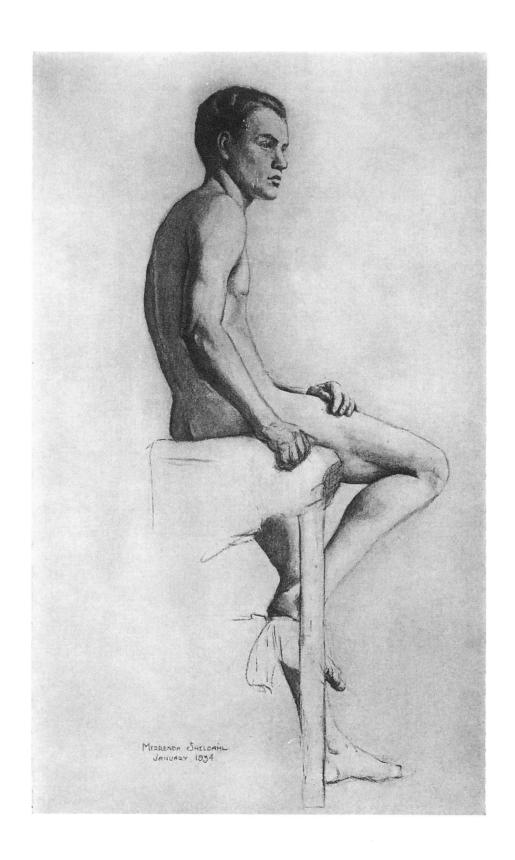

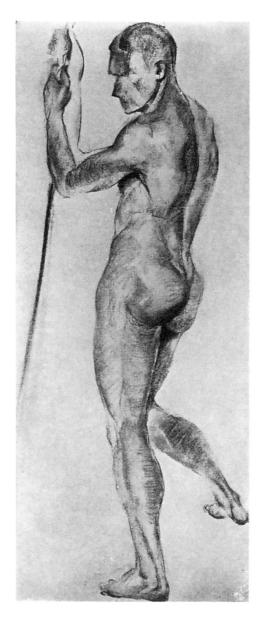

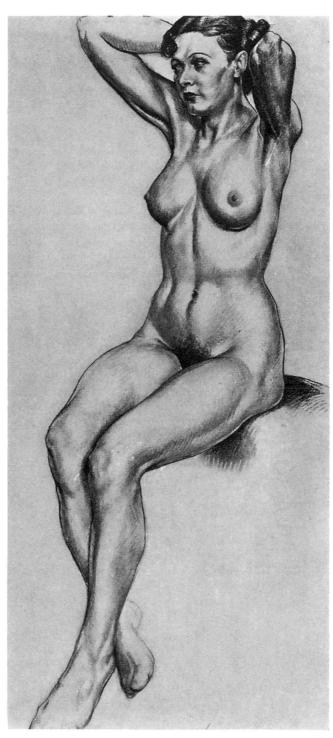

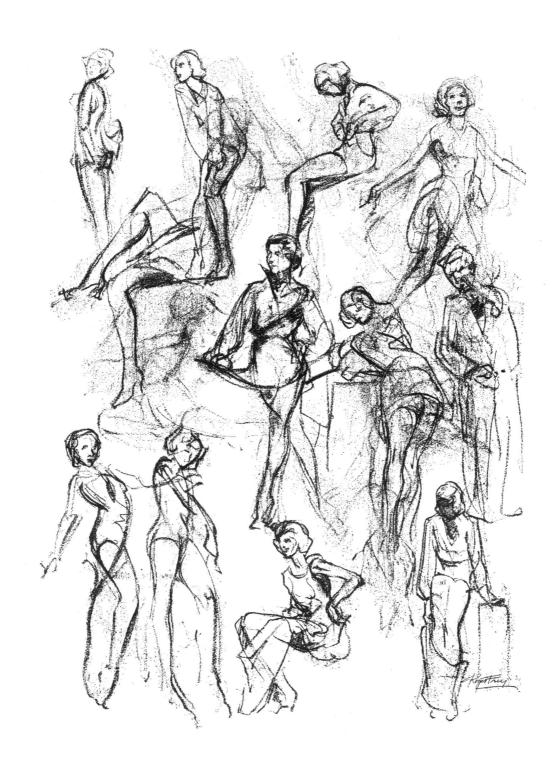

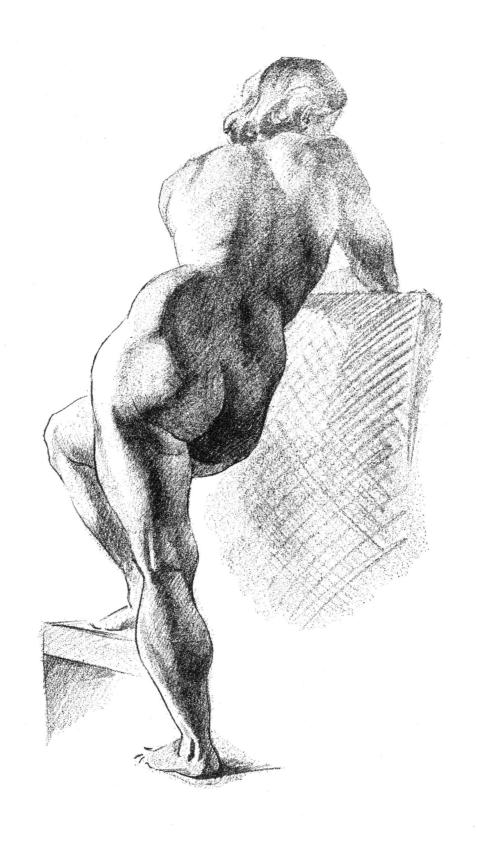

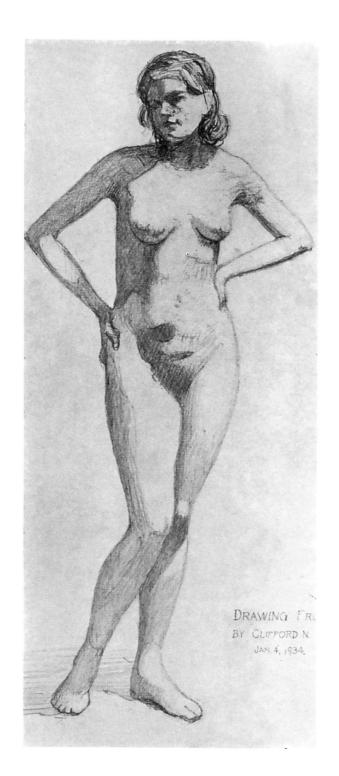

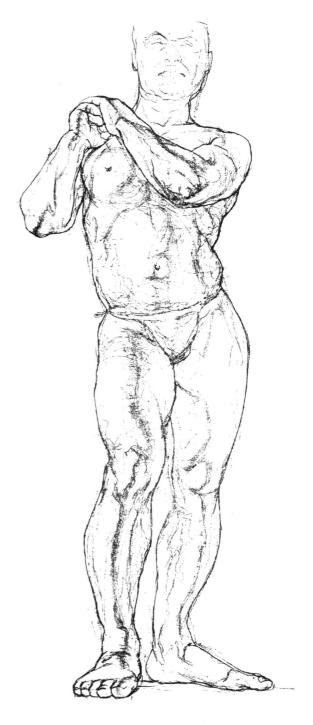

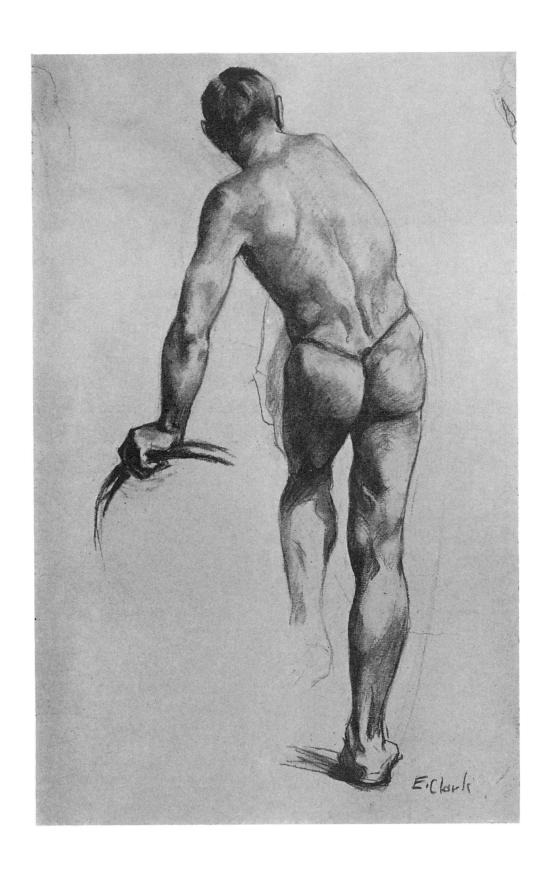

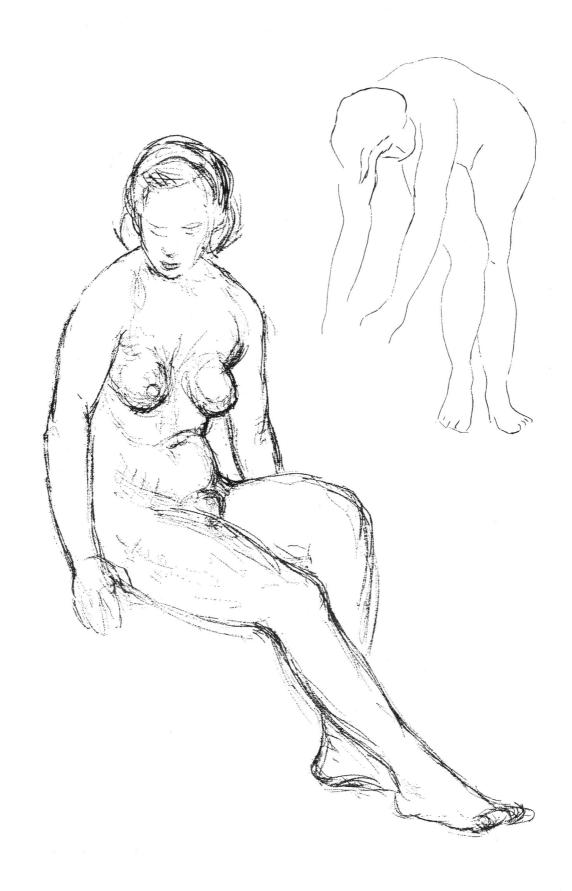

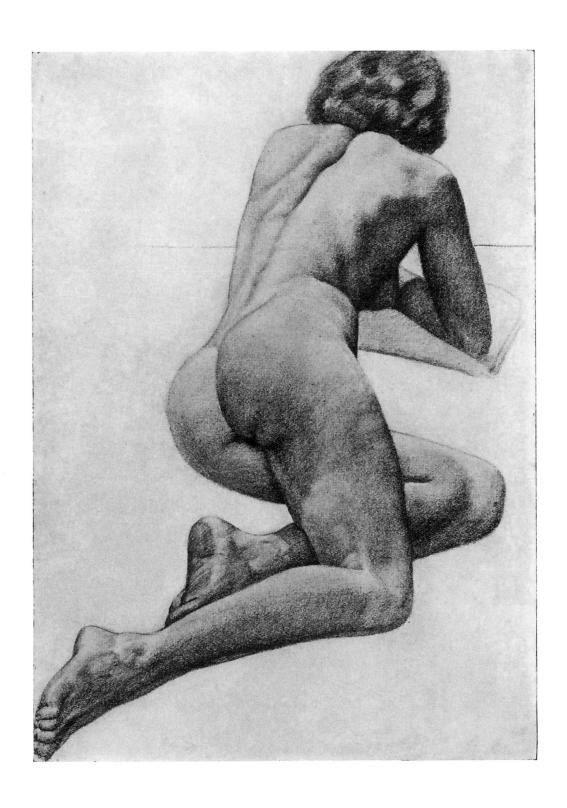

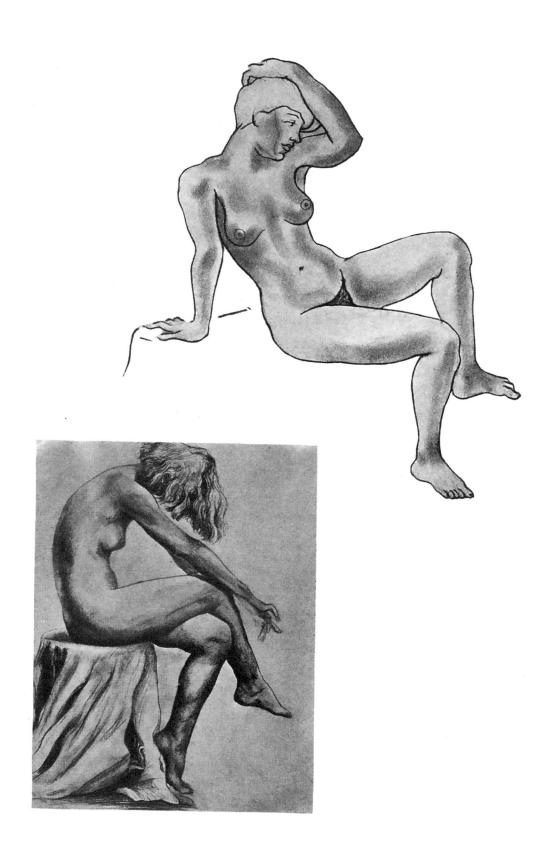

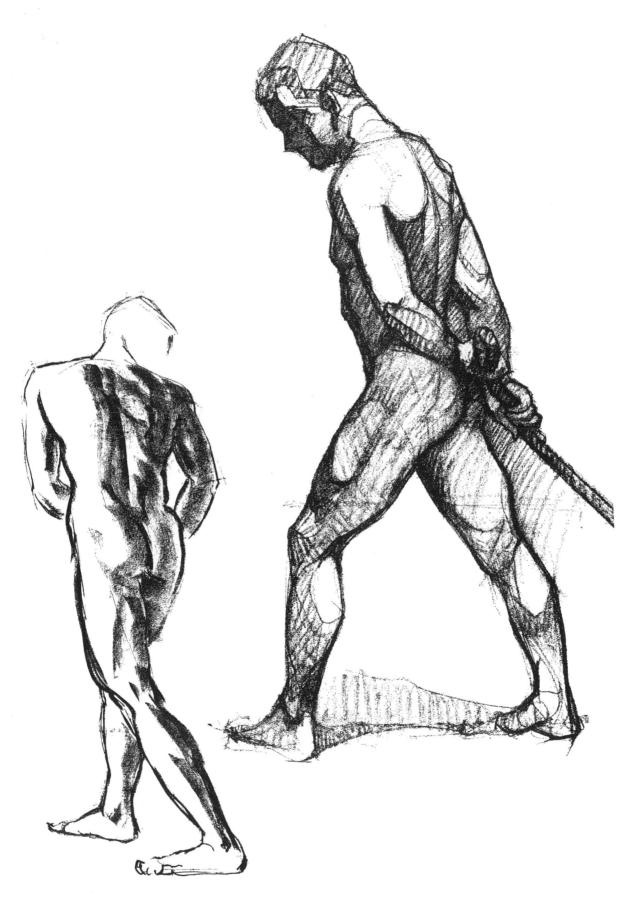

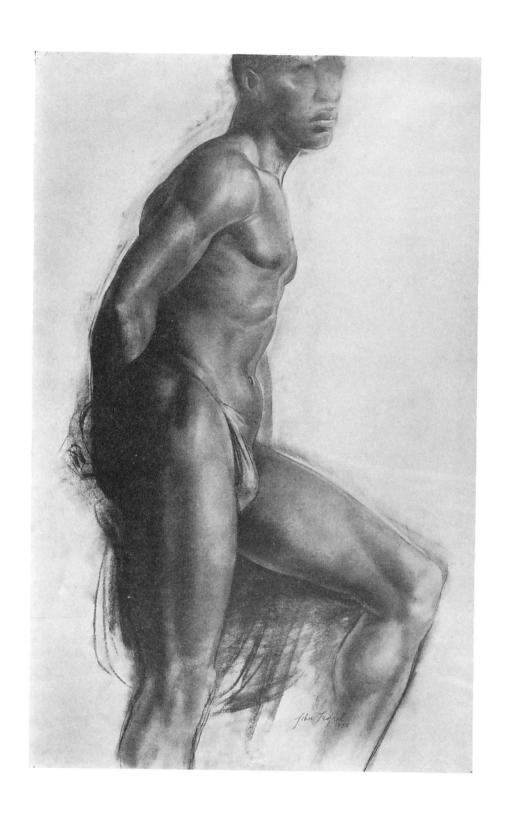

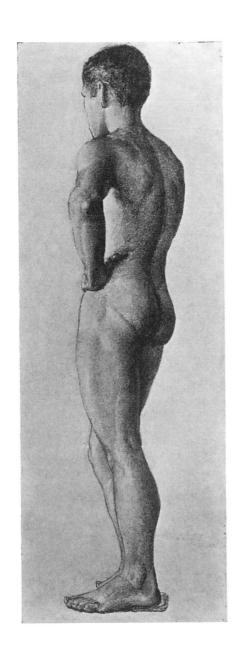

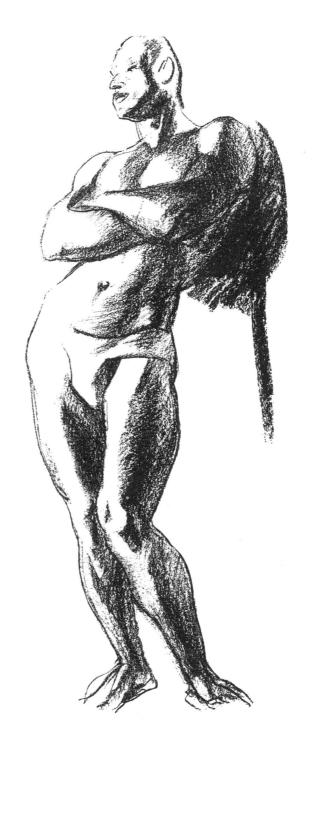

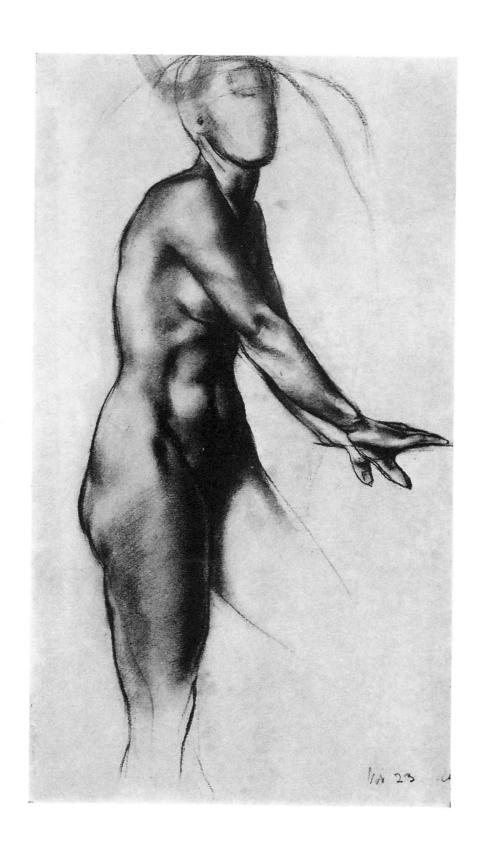

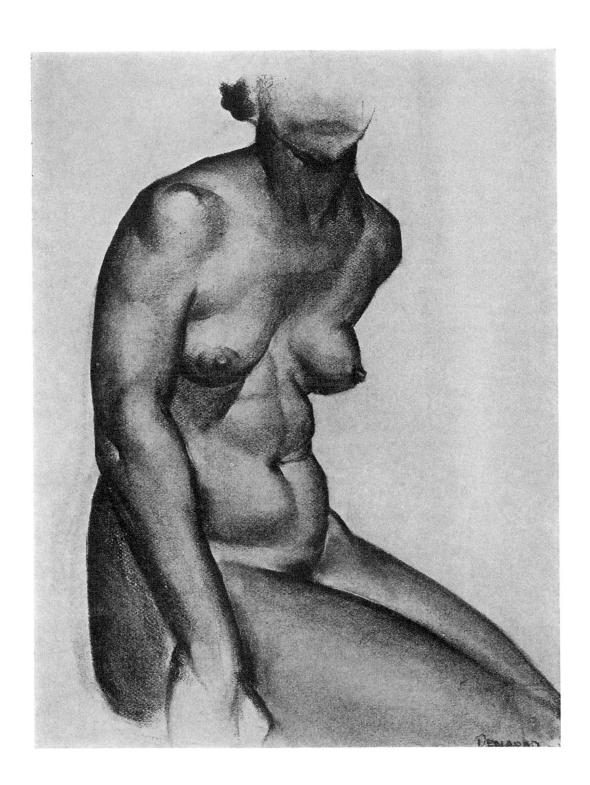

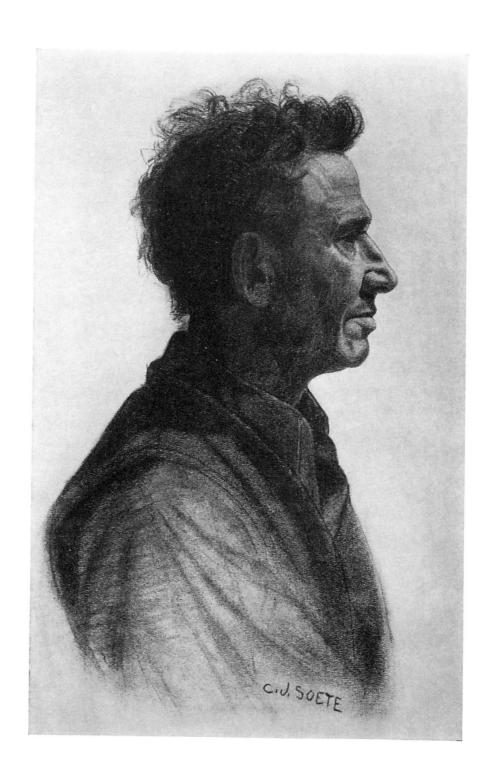

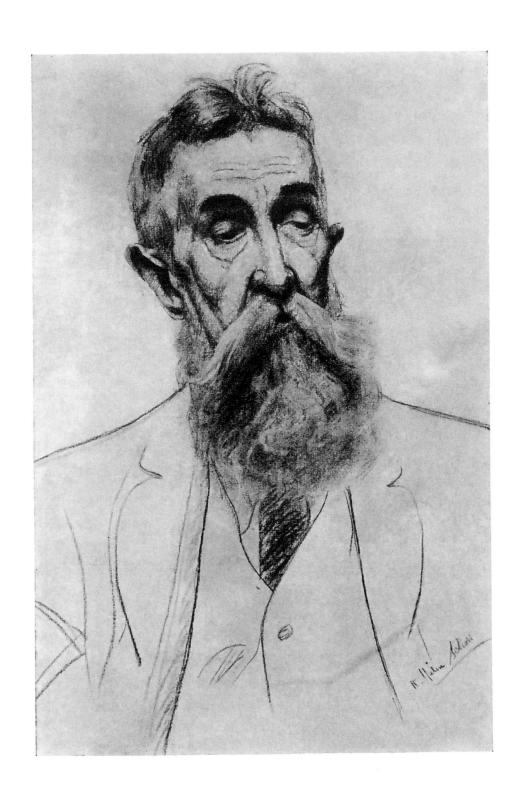

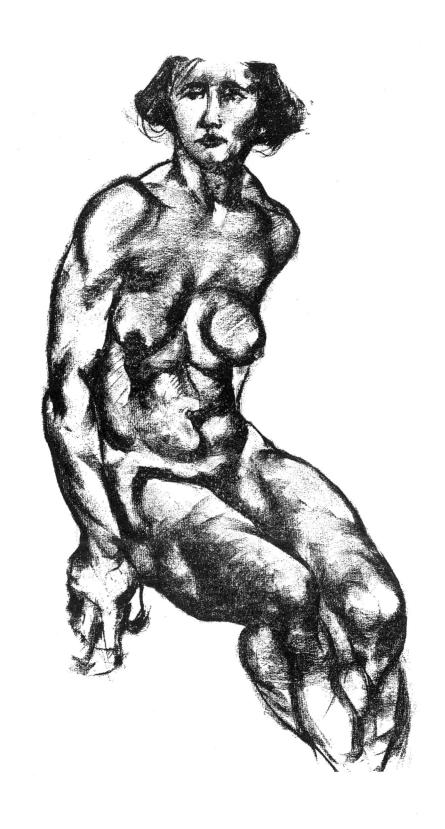

A CATALOG OF SELECTED DOVER BOOKS
IN ALL FIELDS OF INTEREST

A CATALOG OF SELECTED DOVER BOOKS IN ALL FIELDS OF INTEREST

CONCERNING THE SPIRITUAL IN ART, Wassily Kandinsky. Pioneering work by father of abstract art. Thoughts on color theory, nature of art. Analysis of earlier masters. 12 illustrations. 80pp. of text. 5³/₈ x 8¹/₂. 0-486-23411-8

CELTIC ART: The Methods of Construction, George Bain. Simple geometric techniques for making Celtic interlacements, spirals, Kells-type initials, animals, humans, etc. Over 500 illustrations. 160pp. 9 x 12. (Available in U.S. only.)

0-486-22923-8

AN ATLAS OF ANATOMY FOR ARTISTS, Fritz Schider. Most thorough reference work on art anatomy in the world. Hundreds of illustrations, including selections from works by Vesalius, Leonardo, Goya, Ingres, Michelangelo, others. 593 illustrations. 192pp. 7¹/₈ x 10¹/₄. 0-486-20241-0

CELTIC HAND STROKE-BY-STROKE (Irish Half-Uncial from "The Book of Kells"): An Arthur Baker Calligraphy Manual, Arthur Baker. Complete guide to creating each letter of the alphabet in distinctive Celtic manner. Covers hand position, strokes, pens, inks, paper, more. Illustrated. 48pp. 8¹/₄ x 11. 0-486-24336-2

EASY ORIGAMI, John Montroll. Charming collection of 32 projects (hat, cup, pelican, piano, swan, many more) specially designed for the novice origami hobbyist. Clearly illustrated easy-to-follow instructions insure that even beginning papercrafters will achieve successful results. 48pp. $8^{1}/_{4}$ x 11. 0-486-27298-2

BLOOMINGDALE'S ILLUSTRATED 1886 CATALOG: Fashions, Dry Goods and Housewares, Bloomingdale Brothers. Famed merchants' extremely rare catalog depicting about 1,700 products: clothing, housewares, firearms, dry goods, jewelry, more. Invaluable for dating, identifying vintage items. Also, copyright-free graphics for artists, designers. Co-published with Henry Ford Museum & Greenfield Village. 160pp. 8¹/₄ x 11.

0-486-25780-0

THE ART OF WORLDLY WISDOM, Baltasar Gracian. "Think with the few and speak with the many," "Friends are a second existence," and "Be able to forget" are among this 1637 volume's 300 pithy maxims. A perfect source of mental and spiritual refreshment, it can be opened at random and appreciated either in brief or at length. 128pp. 5³/₈ x 8¹/₂.

0-486-44034-6

JOHNSON'S DICTIONARY: A Modern Selection, Samuel Johnson (E. L. McAdam and George Milne, eds.). This modern version reduces the original 1755 edition's 2,300 pages of definitions and literary examples to a more manageable length, retaining the verbal pleasure and historical curiosity of the original. 480pp. 5³/₁₆ x 8¹/₄.

0-486-44089-3

ADVENTURES OF HUCKLEBERRY FINN, Mark Twain, Illustrated by E. W. Kemble. A work of eternal richness and complexity, a source of ongoing critical debate, and a literary landmark, Twain's 1885 masterpiece about a barefoot boy's journey of self-discovery has enthralled readers around the world. This handsome clothbound reproduction of the first edition features all 174 of the original black-and-white illustrations. 368pp. 5^{3} /₈ x 8^{1} /₂. 0-486-44322-1

STICKLEY CRAFTSMAN FURNITURE CATALOGS, Gustav Stickley and L. & J. G. Stickley. Beautiful, functional furniture in two authentic catalogs from 1910. 594 illustrations, including 277 photos, show settles, rockers, armchairs, reclining chairs, bookcases, desks, tables. 183pp. $6^{1}/_{2} \times 9^{1}/_{4}$. 0-486-23838-5

AMERICAN LOCOMOTIVES IN HISTORIC PHOTOGRAPHS: 1858 to 1949, Ron Ziel (ed.). A rare collection of 126 meticulously detailed official photographs, called "builder portraits," of American locomotives that majestically chronicle the rise of steam locomotive power in America. Introduction. Detailed captions. xi+ 129pp. 9 x 12.

0-486-27393-8

AMERICA'S LIGHTHOUSES: An Illustrated History, Francis Ross Holland, Jr. Delightfully written, profusely illustrated fact-filled survey of over 200 American lighthouses since 1716. History, anecdotes, technological advances, more. 240pp. 8 x 10³/₄.

0-486-25576-X

TOWARDS A NEW ARCHITECTURE, Lc Corbusier. Pioneering manifesto by founder of "International School." Technical and aesthetic theories, views of industry, economics, relation of form to function, "mass-production split" and much more. Profusely illustrated. 320pp. 6½ x 9½. (Available in U.S. only.)

0-486-25023-7

HOW THE OTHER HALF LIVES, Jacob Riis. Famous journalistic record, exposing poverty and degradation of New York slums around 1900, by major social reformer. 100 striking and influential photographs. $233pp.\ 10 \times 7^7/8$. 0-486-22012-5

FRUIT KEY AND TWIG KEY TO TREES AND SHRUBS, William M. Harlow. One of the handiest and most widely used identification aids. Fruit key covers 120 deciduous and evergreen species; twig key 160 deciduous species. Easily used. Over 300 photographs. 126pp. $5^{3}/_{8} \times 8^{1}/_{2}$. 0-486-20511-8

COMMON BIRD SONGS, Dr. Donald J. Borror. Songs of 60 most common U.S. birds: robins, sparrows, cardinals, bluejays, finches, more—arranged in order of increasing complexity. Up to 9 variations of songs of each species.

Cassette and manual 0-486-99911-4

ORCHIDS AS HOUSE PLANTS, Rebecca Tyson Northen. Grow cattleyas and many other kinds of orchids—in a window, in a case, or under artificial light. 63 illustrations. 148pp. 5^{3} /₈ x 8^{1} /₂. 0-486-23261-1

MONSTER MAZES, Dave Phillips. Masterful mazes at four levels of difficulty. Avoid deadly perils and evil creatures to find magical treasures. Solutions for all 32 exciting illustrated puzzles. 48pp. 8¹/₄ x 11. 0-486-26005-4

MOZART'S DON GIOVANNI (DOVER OPERA LIBRETTO SERIES), Wolfgang Amadeus Mozart. Introduced and translated by Ellen H. Bleiler. Standard Italian libretto, with complete English translation. Convenient and thoroughly portable—an ideal companion for reading along with a recording or the performance itself. Introduction. List of characters. Plot summary. 121pp. 5¹/₄ x 8¹/₂. 0-486-24944-1

FRANK LLOYD WRIGHT'S DANA HOUSE, Donald Hoffmann. Pictorial essay of residential masterpiece with over 160 interior and exterior photos, plans, elevations, sketches and studies. 128pp. $9^{1/4}$ x $10^{3/4}$. 0-486-29120-0

THE CLARINET AND CLARINET PLAYING, David Pino. Lively, comprehensive work features suggestions about technique, musicianship, and musical interpretation, as well as guidelines for teaching, making your own reeds, and preparing for public performance. Includes an intriguing look at clarinet history. "A godsend," *The Clarinet*, Journal of the International Clarinet Society. Appendixes. 7 illus. 320pp. 5³/₈ x 8¹/₂. 0-486-40270-3

HOLLYWOOD GLAMOR PORTRAITS, John Kobal (ed.). 145 photos from 1926-49. Harlow, Gable, Bogart, Bacall; 94 stars in all. Full background on photographers, technical aspects. 160pp. 8³/₈ x 11¹/₄. 0-486-23352-9

THE RAVEN AND OTHER FAVORITE POEMS, Edgar Allan Poe. Over 40 of the author's most memorable poems: "The Bells," "Ulalume," "Israfel," "To Helen," "The Conqueror Worm," "Eldorado," "Annabel Lee," many more. Alphabetic lists of titles and first lines. $64pp.\ 5^{3}/_{16} \ge 8^{1}/_{4}$. 0-486-26685-0

PERSONAL MEMOIRS OF U. S. GRANT, Ulysses Simpson Grant. Intelligent, deeply moving firsthand account of Civil War campaigns, considered by many the finest military memoirs ever written. Includes letters, historic photographs, maps and more. 528pp. 6¹/₈ x 9¹/₄. 0-486-28587-1

POE ILLUSTRATED: Art by Doré, Dulac, Rackham and Others, selected and edited by Jeff A. Menges. More than 100 compelling illustrations, in brilliant color and crisp blackand-white, include scenes from "The Raven," "The Pit and the Pendulum," "The Gold-Bug," and other stories and poems. 96pp. $8^{3}/8 \times 11$. 0-486-45746-X

RUSSIAN STORIES/RUSSKIE RASSKAZY: A Dual-Language Book, edited by Gleb Struve. Twelve tales by such masters as Chekhov, Tolstoy, Dostoevsky, Pushkin, others. Excellent word-for-word English translations on facing pages, plus teaching and study aids, Russian/English vocabulary, biographical/critical introductions, more. 416pp. 53/8 x 81/2.

0-486-26244-8

PHILADELPHIA THEN AND NOW: 60 Sites Photographed in the Past and Present, Kenneth Finkel and Susan Oyama. Rare photographs of City Hall, Logan Square, Independence Hall, Betsy Ross House, other landmarks juxtaposed with contemporary views. Captures changing face of historic city. Introduction. Captions. 128pp. 8¹/₄ x 11. 0-486-25790-8

NORTH AMERICAN INDIAN LIFE: Customs and Traditions of 23 Tribes, Elsie Clews Parsons (ed.). 27 fictionalized essays by noted anthropologists examine religion, customs, government, additional facets of life among the Winnebago, Crow, Zuni, Eskimo, other tribes. 480pp. 6¹/₈ x 9¹/₄. 0-486-27377-6

TECHNICAL MANUAL AND DICTIONARY OF CLASSICAL BALLET, Gail Grant. Defines, explains, comments on steps, movements, poses and concepts. 15-page pictorial section. Basic book for student, viewer. 127pp. 5³/₈ x 8¹/₂. 0-486-21843-0

THE MALE AND FEMALE FIGURE IN MOTION: 60 Classic Photographic Sequences, Eadweard Muybridge. 60 true-action photographs of men and women walking, running, climbing, bending, turning, etc., reproduced from a rare 19th-century masterpiece. vi + 121pp. 9 x 12. 0-486-24745-7

ANIMALS: 1,419 Copyright-Free Illustrations of Mammals, Birds, Fish, Insects, etc., Jim Harter (ed.). Clear wood engravings present, in extremely lifelike poses, over 1,000 species of animals. One of the most extensive pictorial sourcebooks of its kind. Captions. Index. 284pp. 9 x 12. 0-486-23766-4

1001 QUESTIONS ANSWERED ABOUT THE SEASHORE, N. J. Berrill and Jacquelyn Berrill. Queries answered about dolphins, sea snails, sponges, starfish, fishes, shore birds, many others. Covers appearance, breeding, growth, feeding, much more. 305pp. 5¹/₄ x 8¹/₄. 0-486-23366-9

ATTRACTING BIRDS TO YOUR YARD, William J. Weber. Easy-to-follow guide offers advice on how to attract the greatest diversity of birds: birdhouses, feeders, water and waterers, much more. 96pp. $5^{3}/_{16} \times 8^{1}/_{4}$. 0-486-28927-3

MEDICINAL AND OTHER USES OF NORTH AMERICAN PLANTS: A Historical Survey with Special Reference to the Eastern Indian Tribes, Charlotte Erichsen-Brown. Chronological historical citations document 500 years of usage of plants, trees, shrubs native to eastern Canada, northeastern U.S. Also complete identifying information. 343 illustrations. 544pp. 6^{1} /₂ x 9^{1} /₄. 0-486-25951-X

STORYBOOK MAZES, Dave Phillips. 23 stories and mazes on two-page spreads: Wizard of Oz, Treasurc Island, Robin Hood, etc. Solutions. 64pp. 8¹/₄ x 11.

0-486-23628-5

AMERICAN NEGRO SONGS: 230 Folk Songs and Spirituals, Religious and Secular, John W. Work. This authoritative study traces the African influences of songs sung and played by black Americans at work, in church, and as entertainment. The author discusses the lyric significance of such songs as "Swing Low, Sweet Chariot," "John Henry," and others and offers the words and music for 230 songs. Bibliography. Index of Song Titles. 272pp. 6½ x 9½.

MOVIE-STAR PORTRAITS OF THE FORTIES, John Kobal (ed.). 163 glamor, studio photos of 106 stars of the 1940s: Rita Hayworth, Ava Gardner, Marlon Brando, Clark Gable, many more. 176pp. $8^{3}/_{8}$ x $11^{1}/_{4}$. 0-486-23546-7

YEKL and THE IMPORTED BRIDEGROOM AND OTHER STORIES OF YIDDISH NEW YORK, Abraham Cahan. Film Hester Street based on Yekl (1896). Novel, other stories among first about Jewish immigrants on N.Y.'s East Side. 240pp. 5³/₈ x 8¹/₂. 0-486-22427-9

SELECTED POEMS, Walt Whitman. Generous sampling from *Leaves of Grass*. Twenty-four poems include "I Hear America Singing," "Song of the Open Road," "I Sing the Body Electric," "When Lilacs Last in the Dooryard Bloom'd," "O Captain! My Captain!"—all reprinted from an authoritative edition. Lists of titles and first lines. 128pp. 5³/₁₆ x 8¹/₄. 0-486-26878-0

SONGS OF EXPERIENCE: Facsimile Reproduction with 26 Plates in Full Color, William Blake. 26 full-color plates from a rare 1826 edition. Includes "The Tyger," "London," "Holy Thursday," and other poems. Printed text of poems. 48pp. $5^{1}/_{4} \times 7$. 0-486-24636-1

THE BEST TALES OF HOFFMANN, E. T. A. Hoffmann. 10 of Hoffmann's most important stories: "Nutcracker and the King of Mice," "The Golden Flowerpot," etc. 458pp. $5^{3}/_{8}$ x $8^{1}/_{2}$. 0-486-21793-0

THE BOOK OF TEA, Kakuzo Okakura. Minor classic of the Orient: entertaining, charming explanation, interpretation of traditional Japanese culture in terms of tea ceremony. 94pp. 5³/₀ x 8¹/₂. 0-486-20070-1

A MODERN HERBAL, Margaret Grieve. Much the fullest, most exact, most useful compilation of herbal material. Gigantic alphabetical encyclopedia, from aconite to zedoary, gives botanical information, medical properties, folklore, economic uses, much else. Indispensable to serious reader. 161 illustrations. 888pp. 6½ x 9½. 2-vol. set. (Available in U.S. only.)

Vol. I: 0-486-22798-7

Vol. II: 0-486-22799-5

HIDDEN TREASURE MAZE BOOK, Dave Phillips. Solve 34 challenging mazes accompanied by heroic tales of adventure. Evil dragons, people-eating plants, bloodthirsty giants, many more dangerous adversaries lurk at every twist and turn. 34 mazes, stories, solutions. $48pp.\ 8^{1}/4 \times 11$. 0-486-24566-7

LETTERS OF W. A. MOZART, Wolfgang A. Mozart. Remarkable letters show bawdy wit, humor, imagination, musical insights, contemporary musical world; includes some letters from Leopold Mozart. 276pp. 5^{3} /8 x 8^{1} /2. 0-486-22859-2

BASIC PRINCIPLES OF CLASSICAL BALLET, Agrippina Vaganova. Great Russian theoretician, teacher explains methods for teaching classical ballet. 118 illustrations. 175pp. $5^{3}/_{8}$ x $8^{1}/_{2}$. 0-486-22036-2

THE JUMPING FROG, Mark Twain. Revenge edition. The original story of The Celebrated Jumping Frog of Calaveras County, a hapless French translation, and Twain's hilarious "retranslation" from the French. 12 illustrations. 66pp. 5³/₈ x 8¹/₂.

0-486-22686-7

BEST REMEMBERED POEMS, Martin Gardner (ed.). The 126 poems in this superb collection of 19th- and 20th-century British and American verse range from Shelley's "To a Skylark" to the impassioned "Renascence" of Edna St. Vincent Millay and to Edward Lear's whimsical "The Owl and the Pussycat." 224pp. 5³/₈ x 8¹/₂. 0-486-27165-X

COMPLETE SONNETS, William Shakespeare. Over 150 exquisite poems deal with love, friendship, the tyranny of time, beauty's evanescence, death and other themes in language of remarkable power, precision and beauty. Glossary of archaic terms. 80pp. $5^{3}/_{16} \times 8^{1}/_{4}$. 0-486-26686-9

HISTORIC HOMES OF THE AMERICAN PRESIDENTS, Second, Revised Edition, Irvin Haas. A traveler's guide to American Presidential homes, most open to the public, depicting and describing homes occupied by every American President from George Washington to George Bush. With visiting hours, admission charges, travel routes. 175 photographs. Index. 160pp. $8^{1/4}$ x 11. 0-486-26751-2

THE WIT AND HUMOR OF OSCAR WILDE, Alvin Redman (ed.). More than 1,000 ripostes, paradoxes, wisecracks: Work is the curse of the drinking classes; I can resist everything except temptation; etc. 258pp. 5^{3} /₈ x 8^{1} /₂. 0-486-20602-5

SHAKESPEARE LEXICON AND QUOTATION DICTIONARY, Alexander Schmidt. Full definitions, locations, shades of meaning in every word in plays and poems. More than 50,000 exact quotations. 1,485pp. $6^{1/2}$ x $9^{1/4}$. 2-vol. set.

Vol. 1: 0-486-22726-X Vol. 2: 0-486-22727-8

SELECTED POEMS, Emily Dickinson. Over 100 best-known, best-loved poems by one of America's foremost poets, reprinted from authoritative early editions. No comparable edition at this price. Index of first lines. 64pp. $5^3/_{16} \times 8^1/_{4}$. 0-486-26466-1

THE INSIDIOUS DR. FU-MANCHU, Sax Rohmer. The first of the popular mystery series introduces a pair of English detectives to their archnemesis, the diabolical Dr. Fu-Manchu. Flavorful atmosphere, fast-paced action, and colorful characters enliven this classic of the genre. 208pp. $5^{3}/_{16} \times 8^{1}/_{4}$. 0-486-29898-1

LIGHT AND SHADE: A Classic Approach to Three-Dimensional Drawing, Mrs. Mary P. Merrifield. Handy reference clearly demonstrates principles of light and shade by revealing effects of common daylight, sunshine, and candle or artificial light on geometrical solids. 13 plates. $64pp.\ 5^3/_8 \times 8^{1/_2}$.

0-486-44143-1

ASTROLOGY AND ASTRONOMY: A Pictorial Archive of Signs and Symbols, Ernst and Johanna Lehner. Treasure trove of stories, lore, and myth, accompanied by more than 300 rare illustrations of planets, the Milky Way, signs of the zodiac, comets, meteors, and other astronomical phenomena. 192pp. 8³/₈ x 11. 0-486-43981-X

JEWELRY MAKING: Techniques for Metal, Tim McCreight. Easy-to-follow instructions and carefully executed illustrations describe tools and techniques, use of gems and enamels, wire inlay, casting, and other topics. 72 line illustrations and diagrams. 176pp. $8^{1}/_{4} \times 10^{7}/_{8}$. 0-486-44043-5

MAKING BIRDHOUSES: Easy and Advanced Projects, Gladstone Califf. Easy-to-follow instructions include diagrams for everything from a one-room house for bluebirds to a forty-two-room structure for purple martins. 56 plates; 4 figures. 80pp. 8³/₄ x 6³/₈.

0-486-44183-0

LITTLE BOOK OF LOG CABINS: How to Build and Furnish Them, William S. Wicks. Handy how-to manual, with instructions and illustrations for building cabins in the Adirondack style, fireplaces, stairways, furniture, beamed ceilings, and more. 102 line drawings. 96pp. $8^{3}/_{4}$ x $6^{3}/_{8}$. 0-486-44259-4

THE SEASONS OF AMERICA PAST, Eric Sloane. From "sugaring time" and strawberry picking to Indian summer and fall harvest, a whole year's activities described in charming prose and enhanced with 79 of the author's own illustrations. 160pp. 8¹/₄ x 11. 0-486-44220-9

THE METROPOLIS OF TOMORROW, Hugh Ferriss. Generous, prophetic vision of the metropolis of the future, as perceived in 1929. Powerful illustrations of towering structures, wide avenues, and rooftop parks—all features in many of today's modern cities. 59 illustrations. 144pp. 8¹/₄ x 11. 0-486-43727-2

THE PATH TO ROME, Hilaire Belloc. This 1902 memoir abounds in lively vignettes from a vanished time, recounting a pilgrimage on foot across the Alps and Apennines in order to "see all Europe which the Christian Faith has saved." 77 of the author's original line drawings complement his sparkling prose. 272pp. $5^{3}/_{8}$ x $8^{1}/_{2}$. 0-486-44001-X

THE HISTORY OF RASSELAS: Prince of Abissinia, Samuel Johnson. Distinguished English writer attacks eighteenth-century optimism and man's unrealistic estimates of what life has to offer. 112pp. 5³/₈ x 8¹/₂. 0-486-44094-X

A VOYAGE TO ARCTURUS, David Lindsay. A brilliant flight of pure fancy, where wild creatures crowd the fantastic landscape and demented torturers dominate victims with their bizarre mental powers. 272pp. 5³/₈ x 8¹/₂. 0-486-44198-9

Paperbound unless otherwise indicated. Available at your book dealer, online at **www.doverpublications.com**, or by writing to Dept. GI, Dover Publications, Inc., 31 East 2nd Street, Mineola, NY 11501. For current price information or for free catalogs (please indicate field of interest), write to Dover Publications or log on to **www.doverpublications.com** and see every Dover book in print. Dover publishes more than 400 books each year on science, elementary and advanced mathematics, biology, music, art, literary history, social sciences, and other areas.